LYDIA CABRERA

between
the
sum
and
the
parts

Edited by KAREN MARTA *and* GABRIELA RANGEL
Illustrated by LYDIA CABRERA

AMERICAS SOCIETY
KOENIG BOOKS, LONDON

A Note on Lydia Cabrera

LYDIA CABRERA CLAIMED SHE WAS BORN IN 1900, *a year that saw Cuba's independence come to an end with the final treaties of the Spanish-American War, but a year that also marked, for many of her generation, the beginning of an era that would be the apogee of modern art and culture. However, according to the date on her birth certificate, as well as the date recorded in her Cuban passport, Cabrera was actually born in 1899. Perhaps, just as Jorge Luis Borges did, she added a year to her birthdate to connect her writings and legacy to the nascent century.*

Although Havana was the city of her birth, the myths of Cabrera were born across the Atlantic Ocean, in the Old World where she would rediscover the culture of her home. It was in the Europe of the thirties that she would entertain her ailing lover, the writer Teresa de la Parra, throughout de la Parra's numerous stays in tubercular sanatoriums, with stories from her childhood, remembered as they had been told to her by her caregivers and servants, about the tricks and riddles of the freshwater turtles named jicoteas, the murderous reign of a rapacious bull who had usurped the kingdom of Cocozumba from an earthworm, and the bargainings made and songs and dances performed by a myriad of creatures and characters to forestall death, all spun and embellished from the threads of Cabrera's recollections, to keep her friend's mind away from her failing health and dismal surroundings. At the urging of the French translator and novelist Francis de Miomandre, Cabrera gathered these tales into a book. When the collection first appeared in 1936, readers assumed that

these stories were unaltered transcriptions from the Cuban descendants of the Yoruba and Bantu peoples. Not until her later years did Cabrera reveal that she had, in fact, consciously fabricated most of the collection, to make plain and upend the fetish that the Parisian intelligentsia and artistic elite had made of African art and culture.

While in Paris, Cabrera tried to sustain herself by selling antiques and even her mother's car, but the rising tide of fascism brought her back to Cuba, where she would once again hear and see the music, legends, rituals, and art of the Afro-Cuban people, diligently setting these cultures down so they could spread and persevere in the face of encroaching erasure. Despite modestly insisting that she was neither an academic nor an intellectual, Cabrera extended her explorations and research into the cultures of the African diaspora throughout her life, even when she was forced to leave her home, and, through her correspondence, followed academic discussions on literature, the history of religions, ethnography, and anthropology.

In 1960 she was exiled by the Cuban Revolution, settling down in what she described as the "cultural desert" of Miami, a place where, in her elder years, she had few complaints about going blind since it meant she could avoid seeing how ugly the world around her had become. One of the meager benefits of living in Miami was that she was only ninety miles from her former home. In Cuba, Cabrera's family had been part of the aristocracy, but after her exile a great deal of her time was spent trying to collect money from her publishers, and she began to make ends meet by selling stones she had painted with symbols from Afro-Cuban religions.

Under the persona of Armando Córdova, a heteronym that was the subject of a satirical and fictional piece of art criticism she had written, Cabrera drew Afro-Cuban motifs and symbols as well as fantastic androgynous creatures, which were featured

in catalogues and on book covers, including the cover and illustrations of the book in your hands. Until her death in 1991, she wrote over forty scholarly texts and ten collections of fiction as a prominent member of Florida's community of exiled Cuban writers. Because Lydia Cabrera has been, for the most part, ignored in the United States, as well as in other English-speaking countries, we hope this book will help to draw the reader toward the work, legacy, and myths that she left behind.

—THE EDITORS

Nacían mujeres en Cocozumba; por la voluntad de aquel Toro, nada más que mujeres. Unas que espigaban o ya eran mozas; otras ya eran viejas—y todas las viejas se habían muerto—. Nada cambiaba en Cocozumba; si acaso la única innovación, a partir de cierta época, consistió en eliminar también del lenguaje corriente, el género masculino, cuando no se aludía al Toro. Por ejemplo: allí se hubiera dicho, que se clavaba con la «martilla», se guisaba en la «fogona» y se chapeaba con la «macheta». Un pie, era «una pie»; así, la pela, la ojo, le pecha, la cuella—o pescueza—las diez dedas de la mana, etc. Nadie se hubiera referido al Cielo, sino a la «Ciela»; Ciela abierta…

— LYDIA CABRERA, CUENTOS NEGROS DE CUBA, 1940

Contents

Lydia Cabrera

BETWEEN THE SUM
AND THE PARTS

LYDIA CABRERA

TIME FIGHTS THE SUN AND THE MOON CONSOLES THE EARTH

They say that King Embú is Time and that he married Ensanda, the majestic Ceiba in Guankila. But the beautiful Ensanda was sterile and the king left her, to search for the most fecund woman on earth.

When he got to Tangú-Tangú, the last known town—the world ends there—he found a woman who, without the slightest effort, entirely without pain, gave birth to an incredible number of children before his very eyes.

When this prolific mother rose from the ground and gazed upon her many children, she moaned pitifully and began to weep bitter tears.

King Embú, surprised and puzzled, considering her sudden sorrow exceedingly strange, asked her:

"Why are you crying? What afflicts you, Moana-Entoto, the extraordinary woman who has the good fortune to give painless birth to so many children?"

"I am crying because the resplendent king who fathers them will soon burn them to death."

"Who is this man who would burn his children? Where does this fiery man live?"

"This man is the sun, King Tangú. He lives up above in the Ensuro Savanna with an albino concubine named Gonda who has white eyelashes and an icy mouth, and who is barren."

Embú told her:

"I am Embú, the king who stops at nothing, the king who marches everywhere, through every obstacle. If you give me as many sons as you gave Tangú, I will go up to Ensuro and I will fight him."

"All right," she responded.

So, Tangú and Embú wage an endless war: Tangú fights fiercely all day, vainly trying to paralyze Embú, who advances across his dominion, devouring space with each moment.

Finally, cornered in the farthest reaches of Ensuro, Tangú surrenders and rolls about in pain, bleeding at the bottom of the abyss. He has lost the kingdom that Embú snatched away in hand-to-hand combat. He falls to goodness knows where, to some silent cavern, and there he rests, hidden away.

Embú returns to be with the woman who conceives incessantly, and she gives him millions of sons, as she did to Tangú. Embú remains at her side and seems to rest peacefully, surrounded by her motionless progeny.

The white and silent Gonda appears with her large jar full of dew and compassionately pours it over the belly of the fertile woman whom the jealous sun burns by day; she waters all the sleeping children and because of her, they do not wither. The rooster will sing. Tangú will come back to life radiant, new and powerful.

15

In the desert of Heaven, the eternal battle between King Embú and King Tangú begins once again . . .

Translated by Suzanne Jill Levine and Mary Caldwell

Por qué . . . cuentos negros de Cuba, 1948. Originally translated for *Review* 31 (New York: Center for Inter-American Relations, 1981).

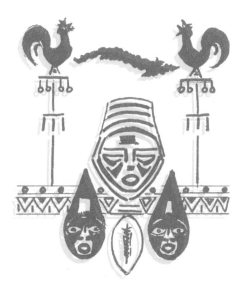

CHRISTOPHER WINKS

CARIBBEAN ANTHROPOETICS

C uban writer and independent scholar Lydia Cabrera's intellectual and creative project, which actively and rightfully situates African-based thought, religious practice, lifeways, and mythology at the very center of Cuban culture, deserves far more critical and scholarly consideration than it has received. Encompassing more than fifty years of publications, this work of recovery and reconstruction stands out for its ambition, depth, range, moral commitment, and stylistic verve — the complete antithesis of pedantry and sobriety. Consider even part of her legacy: four volumes of original "literary" tales inspired largely by Afro-Cuban myth and legend, lexicons of the three major creolized African languages spoken in Cuba (Yoruba,

18 Ki-Kongo, and Ejagham), field recordings of Afro-Cuban sacred music (in collaboration with photographer Josefina Tarafa), an annotated collection of ritual signs from the all-male Abakuá secret society, a study of the powerful aquatic female orishas Yemayá and Oshún, translations into Spanish of the major Négritude poets (notably Aimé Césaire's *Notebook of a Return to the Native Land*, four years after its original publication in France), her own visual artwork, and most significantly, her 1954 magnum opus and seedbed of all her subsequent investigations, El *Monte: Igbo, Finda, Ewe Orisha, Vititi Nfinda*, which, nearly sixty-five years later, remains an indispensable reference for today's practitioners of Ocha and Palo Mayombe throughout the Americas. If Cabrera's brother-in-law, the anthropologist Fernando Ortiz, is, as C. L. R. James describes, "the tireless exponent of Cuban life and *Cubanidad*, the spirit of Cuba, [whose work] is the first and only comprehensive study of the West Indian people...usher[ing] the Caribbean into the thought of the twentieth century and ke[eping] it there,"[1] Cabrera, as tireless and comprehensive as Ortiz, to whom she dedicated El *Monte*, anticipates twenty-first-century rebellions in anthropology against discursive methodologies (such as the positivism and functionalism characteristic of Ortiz's undeniably path-breaking and enduring studies) and a consequent emphasis on the participant-observer's relationship to the voices of her informants. Indeed, it is these voices that shape Cabrera's investigations, to the extent that, as John Szwed and Robert Farris Thompson observe in one of the few English-language evaluations of Cabrera's oeuvre, "in submitting to the responsibility, the incredible repetitiveness of her informant's valuable,

1. C. L. R. James, *The Black Jacobins: Toussaint L'Ouverture and the San Domingo Revolution*, 2nd ed., rev. (New York: Vintage, 1989), 395.

pithy arguments, she made an even greater contribution [than Ortiz]. [...] For she collected whole texts, as it were, whereas Ortiz pigeonholed his facts and worked up essentially an etymology of the main traits of Afro-Cuban lore."[2]

And yet, Cabrera remains, if not wholly ignored, then certainly a submerged presence in Caribbean studies. A recent massive anthology of "Caribbean cultural thought"[3] that brings together a wide range of important and foundational texts, nevertheless leaves her out. And throughout his discussion of "ethnographic surrealism" in his by-now-canonical text of postmodern anthropology *The Predicament of Culture*, James Clifford nowhere mentions Cabrera. Whether or not such omissions have to do with the dearth of English translations of her work (the only one of her books available in English is a translation of *Cuentos negros de Cuba*[4]) or with the fact that she and her life companion and collaborator, the paleographer and architectural historian María Teresa de Rojas, left Cuba in 1960, disillusioned with the direction of the year-old Cuban Revolution, it remains the case that Cabrera demands to be placed in "relation" (in Édouard Glissant's sense of "[a] poetics that is latent, open, multilingual in intention, directly in contact with everything possible"[5]) with other Caribbean (not just Cuban) creative

2. John Szwed with Robert Farris Thompson, "The Forest as Moral Document: The Achievement of Lydia Cabrera," in Szwed, *Crossovers: Essays on Race, Music, and American Culture* (Philadelphia: University of Pennsylvania Press, 2005), 66.

3. Aaron Kamugisha and Yanique Hume, eds., *Caribbean Cultural Thought: From Plantation to Diaspora* (Kingston/Miami: Ian Randle, 2013).

4. Lydia Cabrera, *Afro-Cuban Tales*, trans. Alberto Hernández-Chiroldes and Lauren Yoder (Lincoln/London: University of Nebraska Press, 2005).

I know of two attempts at translating *El Monte* that came to naught (a greatly abridged version of Chapter 2: Bilongo, translated by Elliot Klein and Mark Weiss, was published in *Women and Performance* 5, no. 2 #10 [1992]: 29–43). However, the scholars Ivor Miller and Victor Manfredi have been working on a version of *La Sociedad secreta Abakuá*, which will hopefully enjoy a better fate.

5. Édouard Glissant, *Poetics of Relation*, trans. Betsy Wing (Ann Arbor: University of Michigan Press, 1997), 32.

thinkers, both for her own sake and in order to transcend what the Barbadian poet and scholar Kamau Brathwaite has repeatedly identified as the multiple processes of fragmentation (geopsychic, political, racial, linguistic, phenotypical, perceptual, cultural, etc.) that have bedeviled the Caribbean region's coming to self-consciousness and achieving its best (liberatory) definition.[6]

What transformed Lydia Cabrera from an intelligent, independently minded, artistically gifted young white Cuban woman from a "good" *criolla* family into a champion of black Cuban culture was a combination of the effervescent artistic scene of interwar Paris, where she had gone to study Asian art, and the revival, through her close friendship with the Venezuelan writer Teresa de la Parra, of her childhood memories of stories that her black nanny told her. The times were propitious for exploring the depth and richness of such an oral heritage — the year of Cabrera's arrival in Paris, 1927, was the year the eminent Haitian anthropologist Jean Price-Mars published *Ainsi parla l'oncle*, in which Price-Mars saw in popular Haitian religious and artistic traditions a foundation for a true cultural and political independence. Two years before, the philosopher Alain Locke had published the anthology *The New Negro*. And in subsequent years, revolutionary agitation swept through the Caribbean: resistance to US military occupation in Haiti, the 1933 Cuban Revolution that overthrew Gerardo Machado, and worker agitation in several of Britain's Caribbean colonies, notably Trinidad and Jamaica. Anti-colonial actions and sentiments were important elements of the revolutionary currents in the Parisian metropole — surrealism's "heroic" period was in full swing, inspiring Caribbean creators like Cabrera, Alejo Carpentier,

6. See (Edward) Kamau Brathwaite, "Caribbean Culture: Two Paradigms," in Jürgen Martini, ed., *Missile and Capsule* (Bremen: University of Bremen, 1983), 9–54.

Léon-Gontran Damas, Aimé Césaire, Miguel Angel Asturias (all of whom knew each other), and others to go beneath European veneers and beyond European cultural models and explore the submerged popular—black, indigenous— histories, practices, and traditions of their region.

When Cabrera returned to Cuba on the eve of World War II, she had already begun the research that would eventually culminate in El Monte. Her translation of Césaire's Cahier appeared in 1943 with illustrations by her friend Wifredo Lam, whose turn from cubism to a distinctive and revolutionary style grounded in Afro-Cuban iconography she encouraged. Césaire, in turn, published an enthusiastic preface to the first of her Cuentos negros, "Bregantino Bregantín," in the Martiniquan journal Tropiques, hailing her for successfully conveying "the exiled and tranquil, in short irreducible character, at the margin of civilizations, morals, religions, conventions, of the strange people inhabited by saltpeter and dawns who line the Caribbean shores with the ambiguous shards of their laughter."[7] Indeed, Cabrera's stories throughout her career were marked by a sardonic "black" humor that often subverted bourgeois norms of decorum and order. Her totem animal—effigies of which, in various sizes, decorated her small Coral Gables apartment—was the jicotea, a small freshwater turtle which she syncretized with the Yoruba trickster animal Ajapá, whose gender fluidity, unpredictable and not always conventionally moralistic conduct, cleverness, and supernatural resilience were qualities with which she clearly identified.

But when Cabrera made a more concerted effort to explore the profounder reaches of black cultural practices in Cuba, she had to struggle against the deeply rooted,

7. Aimé Césaire, "Introduction à un conte de Lydia Cabrera," Tropiques, no. 10 (February 1944): 11; in Tropiques, Tome II, Nos. 6–7 à 13–14, Février 1943 à Septembre 1945 (Paris: Jean-Michel Place, 1978), my translation.

dismissive prejudice against "*cosas de negros,*" deemed inherently backward and uncivilized. Fernando Ortiz, in his writings about music, had to persistently combat the accepted critical opinion that black people were capable only of "noise." White children were told frightening tales of *diablitos* or Abakuá ñáñigos poised to kidnap, slaughter, and eat them in bloody ceremonies. While black Cubans had been at the forefront of the country's long struggle for independence from Spain, slavery was not abolished until 1886, and the aftermath of a bitter war in 1898 led not to the incorporation of black people as equal participants in rebuilding the nation, but to their further marginalization and repression (fostered as well by the United States' occupation). Growing up in a liberal family—part of the generation of 1868, the year that saw the opening salvo in the independence struggle—Cabrera met people like the black politician Juan Gualberto Gómez, a friend of José Martí, and had more convivial interactions with her family's black servants from childhood than what was likely the norm among scions of wealthy white families. But simply having friendly relationships with subalterns is one thing; crossing the racial and cultural line to learn from them and indeed respect them as teachers is quite another. Possibly it was Cabrera's own sense of marginality as a queer woman in a socially conservative milieu that drew her closer to those whom dominant society mocked, scorned, dismissed, or ignored. Whatever the case, Cabrera's marvelous spiritual openness enabled her to form relationships "rendered in terms of long-time mutuality of service and favor, without the self-serving fanfare that marks some scholars' attempts to set themselves up as paragons of cultural camaraderie and inside observation."[8] In the process, she showed that

8. Szwed and Thompson,
"The Forest as Moral Document," 73.

culturally, many so-called "white" Cubans were blacker in their language and practices than they preferred to think. Indeed, Cuban popular music—exemplified by, among others, Rita Montaner, the Trio Matamoros, Bola de Nieve, Arsenio Rodríguez, Beny Moré, and Miguelito Valdés—was replete with allusions to Afro-Cuban religious practices and even Ki-Kongo, Yoruba, and Ejagham phrases. Cabrera in effect carried out a return to the plural source, the variegated *fundamento*, of Cuban culture: the African presence. In the process, she exemplified Glissant's "surprising resolution" about creolization: "I change in order to exchange with the other, without, however, losing or distorting myself."[9]

C. L. R. James once declared that, despite the massive effort of deculturation inflicted by the master class on the enslaved African arrivants to the region, "We had brought ourselves. We had not come with nothing."[10] Exploring more profoundly the lineaments of what the Africans had "come with," Kamau Brathwaite conceptualizes an elemental breath and bone-structure seed-nucleus he calls *nam*: "the word we give to the indestructible and atomic core of man's culture. [...] We are talking ... of an indwelling, man-inhabiting (not hibiting) organic force (*orisha, loa*) capable of cosmological extension ... which is or can be reductive like unto the shards of Kalahari sand."[11] The gods traveled with and shared the ordeals of their votaries on the Middle Passage, and often their powers were contained—encapsulated—in stones, earth, and scraps transported from Africa to the New World: one of Cabrera's informants, Conga Mariate, constructed an Osain (orisha of medicinal plants) using, among other

9. Glissant, *Poetics of Relation*, 66.

10. C. L. R. James, "The Making of the Caribbean People," *Spheres of Influence* (London: Allison & Busby, 1980), 187.

11. (Edward) Kamau Brathwaite, "Gods of the Middle Passage: A Tennament," *Caribbean Review* II:4 (Fall 1982): 18.

elements, "an old piece of iron, of African provenance."[12] Religious practices and their associated pantheons, liturgies, and languages, however much altered and submerged beneath the pressures of the Plantation system, nonetheless maintained a link with Africa that was transmitted to subsequent generations, and Catholic imagery and rites were integrated (sometimes strategically, sometimes voluntarily) into the constantly creolizing faiths. Sylvia Wynter's dichotomy of plantation and plot is useful here: "African peasants transplanted to the plot all the structure of values that had been created by traditional societies of Africa. [...] Because of this traditional concept the social order remained primary. Around the growing of yam, or food for survival, [the African] created on the plot a folk culture—the basis of a social order, in three hundred years. This culture recreated traditional values—use values. The folk culture became a source of cultural guerrilla resistance to the plantation system."[13]

In the Cuban context, such a folk culture was also an urbanized culture, as witnessed in Cabrera's focus (not, however, an exclusive one) on Havana. Likewise, the process of creolization never simply involved the collision of an undifferentiated "African" culture with a monolithic Euro-plantation model but rather involved a process of what Brathwaite has called (as a preferred alternative to "creolization") *interculturation* among the transplanted Africans, evidence of which abounds in El *Monte*: many of Cabrera's informants/teachers are conversant in Congo, Arará, and Lucumí languages, cosmologies, and performative practices. Commendably, Cabrera, far from attempting to dispel, clarify, or rationalize the complexities of this linguistic

12. Lydia Cabrera, El *Monte* (Miami: Ediciones C. R., 1992), 102; my translation.

13. Sylvia Wynter, "Novel and History, Plot and Plantation," *Savacou* 5 (1971): 99–100.

web, allows her guides the right to their opacity and frequently dispenses with translation altogether; if Glissant proclaimed, "I write in the presence of all the languages of the world. They resound with each other's obscurities, echoes, and silences,"[14] Cabrera textually activates the presence of several languages and their endlessly multiplying variants ("when creolization is accomplished, creole languages no longer tend to disappear, they proliferate on and by themselves ... "[15]), so that readers are able to get a strong impression of the diversity of voices, their inflections, their effortless multilingualism: an admirable confirmation of Brathwaite's observation that "the new language structure" that entered the Caribbean with the enslaved Africans "consisted of many languages, but basically they had a common semantic and stylistic form."[16] The very word *monte* is polysemic and thus untranslatable; it conveys the combined meanings and associations of "wilderness," "jungle," and "mountain," and may best be described as a thronged, teeming, and sometimes monstrous and fearful place of healing, revelation, and/or retribution, the place where the orishas and spirits of the dead dwell, their powers contained in the numerous herbs and plants that grow there, and to whom certain trees are sacred. In keeping with Brathwaite's concept of *nam* as both capable of extension and reduction, a patio garden or vacant urban lot—or a graveyard, for adepts of Palo Monte—can also become incarnations of the *monte*.

In this regard, to call *El Monte* a "Bible," as many have done, is misleading; rather, it exemplifies Glissant's concept, elaborated in *Poetics of Relation*, of the "open word" emerging from the "closed place" of the Plantation (and its

14. Édouard Glissant, *Philosophie de la relation: poésie en etendue* (Paris: Gallimard, 2009), 80; my translation.

15. Ibid., 65.

16. (Edward) Kamau Brathwaite, *History of the Voice: The Development of Nation-Language in Anglophone Caribbean Poetry* (London/Port of Spain: New Beacon, 1984), 7.

sequelae): myths, fables, legends, reminiscences, recipes, songs, and herbal remedies compose a choral ensemble (modestly designated by Cabrera in her book's subtitle as "notes") in which the juxtaposed voices (often anonymous) and overlapping accounts often differ yet are seamlessly integrated into the narrative texture through Cabrera's adroit style. Nor is it a simple transcription of the oral into the scribal, as there are occasional references to written texts, the *libretas sagradas*, which appear at a social stage in which scribal forms enter into, without entirely supplanting, the transmission and alteration of oral explications and which function as combined dream-books, *aides-mémoire*, and lecture notes. Additionally, the frequently referred to sign systems of Congo "firmas" and Abakuá "anaforuana" indicate that other modes of literacy, other kinds of written text, are at work in creolized Afro-Cuban cultures.

Writing about Cabrera's second published collection of tales, *Por qué*, the Spanish philosopher María Zambrano declared, "Lydia Cabrera stands out among all Cuban poets for a form of poetry in which knowledge and fantasy harmonize to the point of no longer being different things, to the point of forming what we call 'poetic knowledge.'"[17] It is this poetic knowledge that permeates *El Monte*, and it is also a key to her method. While it was Guillermo Cabrera Infante who dubbed her an "anthropoet," writers like Zambrano and Gastón Baquero spoke of her in similar terms. Hers is a work of poetic synthesis, not of classifications or paradigms. That she was able to break through racial barriers and gain the confidence of her teacher/informants has everything to do with the respect and courtesy she showed them in approaching them on their own terms. "It takes a

17. María Zambrano, "Lydia Cabrera, Poeta de la Metamorfosis," in *Islas*, ed. Jorge Luis Arcos (Madrid: Verbum, 2007), 119; my translation.

while to understand their euphemisms, their superstitions about language, because there are things that must never be said clearly, and one must learn to understand them, that is, *to learn to think like them*" (my emphasis).[18] It was also important that these elders and adepts were her neighbors: the Quinta San José, the restored colonial house where Cabrera and Titina de Rojas lived in Marianao, adjoined the black working-class neighborhood of Pogolotti. Just as Cabrera's teachers visited and sometimes stayed in her home, she also called on them in their modest dwellings and gave them generous financial assistance when needed. In her preface to El *Monte*, Cabrera acknowledges that "the only value of this work . . . consists exclusively in the genuinely direct role taken in it by the blacks themselves. They are its true authors,"[19] and she calls their names, acknowledging as well and thanking for their trust those who refused to be named lest word get out to their fellow adepts that they had betrayed secrets. Even those who tried to pull the wool over her eyes are thanked, because "their mystifications were no less interesting and implausible."[20]

Three women in particular stand out among her informants: Teresa M., Calixta Morales, and Ma Francisquilla Ibañez. Teresa M. was Cabrera's family's seamstress and had been brought up by two white spinsters "in the house." When Cabrera ventured to ask her some questions about her Mina/Lucumí ancestry, Teresa responded sharply that she couldn't possibly know about "black things," fearing that Cabrera would use such knowledge to mock her, but when it became clear that such was not the case, she introduced Cabrera to her close friend Calixta Morales, Oddedei, a "slim and elegant black woman, very dignified,

18. Cabrera, El *Monte*, 8.
19. Ibid., 10.
20. Ibid., 11.

of pure 'orilé,' lucumí lineage, an aristocrat . . . [whom] I met at a time when she was going through many trials, but, as she said, 'with her head held high.'" This formidable elder "spent an entire afternoon observing me, with silences she prolonged with a smile showing tiny clenched teeth . . . or with timely dodges"[21] but eventually decided that the white woman met with her approval. The old women took Cabrera to an *asiento*, where a novitiate is crowned with his or her tutelary and protective orisha, and an astonished Cabrera witnessed the woman her family knew as "Teresa la negrita," but whose "true-true name" was Omí-Tomí, become possessed with her god and dance for hours. Both Oddedei and Omí-Tomí urged Cabrera to go to Matanzas, "the Mecca, the Lucumí Rome," an area where many *centrales* or sugar mills had been built and whose older denizens retained memories of Africa, and where, as a result, "the African legacy is conserved in its purest form."[22]

Cabrera had never herself become initiated into any of the religions she had studied, precisely so that she could write about each of them without constraint. But on a research trip to Matanzas with her fellow anthropologists Pierre "Fatumbi" Verger (himself a *Babalawo*, much to the amazement of the Matanceros) and Alfred Métraux, and her friend and assistant Josefina Tarafa, Cabrera renewed her friendship with Ma Francisquilla Ibáñez, "that other stupendous old Matancera woman who still had the strength to dance and sing to her gods three days running with her hundred-year-old body that the drums revitalized," and on this visit, she led Lydia to the Laguna Sagrada del Socorro. What followed, recalled in exile at several years' remove, is worth quoting in full, inasmuch as it is a quintessential

21. Ibid., 27.
22. Lydia Cabrera, *La Laguna sagrada de San Joaquín*, (Madrid: Ediciones R., 1973), 8; my translation.

moment of the "marvelous real" to which Cabrera had become attuned through her Afro-Cuban intermediaries, and brings her via her totem animal Ma Jicotea into the heart of what Glissant would call the trembling of the world, manifesting itself in the power of the goddess of the lagoon:

> On this gray day, the milky, quiet waters, unfathomable waters, they assure us in the municipality, tremble at our approach. The lagoon seems to have awakened and blinks in surprise when it notices us.
>
> It is inhabited by thousands of jicoteas, small foot-long turtles that periodically bite and break the glassy surface. They are mysterious creatures, half-supernatural, with indecipherable markings on their spherical, rocky bodies. In reality, they are the daughters of fire, not water, but they live in the rivers so as not to burn up.
> [...]
> Leaning over the water's edge, [Ma Francisquilla] draws me toward her, with a beautiful gesture she presents me to the water and forces me to humble myself, imperiously supporting her rough, dry hand on my neck. She spoke in Lucumí to the goddess dwelling in the depths.
>
> She explained—I could understand her—that the "eleyó, the obiní oibó," the white stranger woman, had come to salute her. And she insisted with persuasive compassion, in the tone one uses to speak to children in order to convince them:
>
> "Obiní eleyibó omó etié. Omó etié Iyamí olodomí."
>
> The white woman is also your daughter, she's your daughter, my mother, Lady of the Water. There followed a lengthy prayer whose words I could only partly grasp. This phrase: "ma oto kokán kokán" (I beseech you with all my heart). She was praying for her and for me in a low voice with intense fervor, absorbed, her hand like the bark of an old tree continuing to force me to remain in an attitude of adoration before the goddess listening to her and perhaps appearing before her simple gaze. And for a moment the old woman's ingenuous, humble mysticism, with such deep roots in nature, the sensation of finding ourselves in a virgin world, facing a mystery, caused the welling up of a fear forgotten in the most ancient part of the "obiní oibó's" soul, or in what of childhood remained in her soul.[23]

23. Ibid., 17.

Kamau Brathwaite describes such moments as "simply a legba or *limbo* or *lembe* x-perience: the sudden or apparently sudden discovery of threshold or watergate into what seems 'new' because it's very ancient; becomes palpable of infinite detail, if necessary; where the 'real' ... has entered continuum, holding w/in its great wheel all the 'tenses' — pastpresentfuture ..."[24] Cabrera's awe, her plumbing of deepest childhood memory, awakened by the powers of the *monte* channeled by a black woman born into slavery, serves as a poignant reminder in the present fraught moment, when the *monte* is being systematically ravaged by the unchecked forces of a "development" that in fact amounts to a spirit-offending regression. Already in the 1950s, Cabrera had warned against the forces of urban growth that were cutting down sacred trees and covering green areas with concrete and soulless architecture, and in her final years of exile in Coral Gables, she remarked to an interviewer that one good thing about going blind was that she no longer had to see Miami.

What the Palo and Ocha adepts cited in El Monte can teach everyone, regardless of one's faith or lack thereof, is a proper respect for the forces of nature, which is of vital importance in an era of global warming and extreme weather, whose destructive consequences have been felt with particular violence in the Caribbean: "[The *Monte*] engenders life, 'we are children of the *Monte* because life begins there; the Saints are born from the *Monte* and our religion is also born from the *Monte*,' says my old herbalist Sandoval [...] 'Everything can be found in the *Monte*, the foundations of the cosmos, and everything must be asked for from the *Monte*, which gives us everything.'"[25]

24. Kamau Brathwaite, *MR/Magical Realism* 1 (New York/Kingston: Savacou North, 2002), 97.

25. Cabrera, El Monte, 13.

More than half of El *Monte* is taken up by an alphabetical listing of all the herbs used for healing (and for inflicting death-dealing illnesses or crippling curses—the world of the *monte*, reflecting its devotees' violent slavery past and stubborn resistance, is not a New Age utopia), with their effects, recipes for their preparation, their associated deities and spirits, relevant tales and proverbs, and nomenclatures in creolized Yoruba, Ki-Kongo, Fongbe (Arará), and Ejagham—and Latin botanical classifications. Perhaps it is time to go *forward* by recovering on a larger scale the traditional Afro-Cuban worldviews that Lydia Cabrera described so respectfully and sympathetically. This could be called a nostalgia for the future, but then again Elegguá, the orisha of crossroads, invoked at the beginning and end of every gathering of santeros, holds the keys to that future: "it's in his hands to lose or save whoever he pleases."[26] And since Elegguá is closely linked to the orisha of herbalists Osain, he is the one who must be propitiated in order to open the path toward a radically transformative reversal of the course of the world (trickster-style) grounded on a poetic knowledge—poetry in extension, as Glissant puts it—that works with nature instead of destroying it through instrumentalized domination.

26. Ibid., 77.

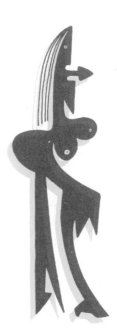

GABRIELA RANGEL

HER PHANTOM CUBA

The archive is not a principle but a malady.[1] Lydia Cabrera was a modern archivist whose determination allowed her to challenge the death drive, mask her difference, and overcome the planetary commotion of the Cuban Revolution: her influence spans from Ana Mendieta to Mestre Didi, Reinaldo Arenas, and Guillermo Cabrera Infante, who stated that Cabrera's *El Monte* was possibly the most important book ever written in Cuba. José Lezama Lima wrote that Cabrera's name evoked "magical associations to the Enlightenment" and compared her

1. Jacques Derrida explained the inextricable connection between the archival impulse and the death drive: "[T]he death drive is not a principle. It even threatens every principality, every archontic primacy, every archival desire. It is what we will call, later on, *le mal d'archive*, archive fever." Jacques Derrida, "Archive Fever: A Freudian Impression," trans. Eric Prenowitz, *Diacritics* 25, no. 2 (Summer 1995): 14.

philological-naturalist scope to that of Alexander von Humboldt.[2] My first encounter with the work of Cabrera, a brilliant and somehow unknown writer-ethnographer, provided a warning about the myths of an expunged authorial or artistic legacy. It occurred thirty-five years ago, during an archival juncture, when I volunteered to serve as a Trojan horse of sorts to facilitate an introduction for a friend who was conducting a biographical study of the Venezuelan writer Teresa de la Parra, the nom de plume of Ana Teresa Parra Sanojo, who was presumably Cabrera's lover.[3]

De la Parra wrote two novels: *Iphigenia, The Diary of a Young Lady Who Wrote Because She Was Bored*, a Bildungsroman, and *Mama Blanca's Memoirs*, as well as a few short stories and essays. *Iphigenia* was published in 1924, inspiring a great regional scandal for its proto-feminist critique of the moral and intellectual limitations of rural life and the provincial conventions of the local upper class, as well as of the submissive role of women within a patriarchal society who are confined by hierarchies and a system of social exclusion. For a long time, de la Parra remained a relatively obscure writer in her motherland, as compared to her contemporary Rómulo Gallegos, for example; however, in the 1980s she became a central figure for a generation of postmodern writers interested in feminist, queer, and gender issues. At the height of her popularity, *Iphigenia* was adapted into a *film d'auteur* scripted by a group of young intellectuals, and the novel was also turned into an exceptionally popular television serial.

2. José Lezama Lima, "El nombre de Lydia Cabrera," *Noticias de Arte* (1982): 3. First published in José Lezama Lima, *Tratados en la Habana* (Havana: Universidad Central de Las Villas, Departamento de Relaciones Culturales, 1958).

3. A writer who lived most of her adult life between Spain, France, and Switzerland, Teresa de la Parra was born in Paris and raised on the outskirts of Caracas in a colonial hacienda owned by her family.

My friend's goal, all those years ago, was to get access to de la Parra's relative, the legal executor of the writer's estate as well as the custodian of her personal papers, which included letters, manuscripts, and diaries. Fortuitously, at the time, I was acquainted with the son of de la Parra's descendant. When I asked to see his mother, in order to talk about de la Parra, he was extremely cautious about the issues to be discussed. He suggested sending topics in advance and advised me to limit the conversation to the writer's literary work. Despite his reticent initial reaction, he received us one morning at their house, which was located in a charming spot in Caracas, facing a golf course with a monumental view of Avila Mountain. Fifteen minutes after our arrival, he escorted us from the main entrance to a terrace, where his mother was already waiting for us. She gave us an obligatory smile and made a quick joke about de la Parra's pervasive legend in Venezuelan society as a rebel woman. She talked about de la Parra's feminine taste for good society, fashion, and literary salons in Europe. Her son and I engaged in a casual conversation to distract from potential tensions, and my friend started to break the icy encounter by asking about de la Parra's family, eliciting details that have blurred in my memory. The conversation focused on tedious genealogical issues rather than on more serious matters. When our host seemed more at ease, having let down her guard a bit, my friend mentioned the name of Lydia Cabrera, followed by others, including Francis de Miomandre and Gabriela Mistral, in relation to the profuse epistolary production of the writer's circle that survived de la Parra's short life (she died at the age of forty-seven).[4] From the 1920s until

4. For Sylvia Molloy, de la Parra's illness led to "one of the busiest epistolary existences imaginable." See Sylvia Molloy, "Disappearing Acts: Reading Lesbian in Teresa de la Parra," in E. Bergman and P. J. Smith, eds., ¿Entiendes?: Queer Readings, Hispanic Writings (Durham, NC: Duke University Press, 1995), 231.

her death, de la Parra was a famously devoted letter writer, inspiring Cabrera to call her the South American version of Madame de Sévigné. Our host responded, in a very dry manner, that some documents were simply not available and others had disappeared because she made sure to destroy them, foremost among them being Cabrera's letters to de la Parra.[5] "I burned them a long time ago," she said defiantly, "I think it was the best decision. Nobody should read them ... they were part of a private correspondence."

No document remains private unless it is destroyed (or never reproduced and shared). However, technology's potential to make the private public is the ghost inside the machine. Jacques Derrida's admonition about the Freudian death impulse as a force rather than a principle that is inextricably intertwined with the archival lingers at the scene of the destruction of Cabrera's letters to de la Parra. Derrida argues that the death impulse:

> destroys in advance its own archive, as if that were in truth the very motivation of its most proper movement. It works to destroy the archive: on the condition of effacing but also with a view to effacing its own "proper" traces—which consequently cannot properly be called "proper." It devours it even before producing it on the outside.... It will always have been archive-destroying, by silent vocation.[6]

Personal papers, which time transforms into archival documents, are typically opaque and tangled as they are often resistant to disclosing invisible paths undertaken during people's lives. De la Parra's biographical researcher was driven to get a sense of the depth and length of the writer's relationship with Cabrera, which was elusive in part because the private matters discussed in their

5. De la Parra used the affectionate nickname Cabrita (little goat) to address Cabrera in most of the numerous letters she sent to her, toying phonetically with Cabrera's last name but also implying the wild and youthful nature of her personality.

6. Derrida, "Archive Fever," 14.

letters were incomplete due to destruction, censorship (occasionally self-censorship), or loss during Cabrera's exile. As Sylvia Molloy aptly argues, there is a project of erasure applied to de la Parra's life and implemented by critics, the writer's family, and, in more than one aspect, by herself. Molloy explains:

> Another reading of Teresa de la Parra here [would be], without forcing prejudiced conventions—a necessary lover, an obligatory femininity—onto a vital void that is merely the result of anxi-ety-ridden erasure, but without overlooking, either, the precise way in which that erasure has been affected. I wish to look closely at a writer whose life has been truncated by critics (I could have done the same with Gabriela Mistral), taking into account not only her fiction but other texts, letters, diaries expurgated by "friendly hands" as the saying goes in Spanish, and, on more than one occasion, by the hands of de la Parra herself.[7]

I also observed Cabrera's role in this erasure in the many layers of cuts that I found in her papers, which I accessed during their public afterlife in the archives of the Cuban Heritage Collection at the University of Miami Libraries. The gaps produced by the operation of erasure pose a number of challenges to researchers of Cabrera's work. It would be a fascinating subject for any biographer or critic, to explore the nuances of the strong bond forged between the young and vital Cuban and de la Parra—who was a decade older and suffering terribly from tuberculosis during her last years. Cabrera accompanied de la Parra to gloomy Swiss hospitals in the Alps, eventually settling with her in Spain, where the Venezuelan writer died in 1936. Referring to de la Parra's confinement in the hospital located in Leysin, Switzerland, Cabrera described her as "the beautiful and sweet prisoner of Leysin's mist."[8] In different interviews, she often mentioned the four-year period spent in the quiet environments of Swiss

7. Molloy, "Disappearing Acts," 233.

8. Lydia Cabrera, in Rosario Hiriart, ed., *Cartas a Lydia Cabrera* (correspondencia inédita de Gabriela Mistral y Teresa de la Parra) (Madrid: Torremozas, 1988), 9.

sanatoria, saying that she was there only to bring company to her "friend," who was lonely and required her attention. During this period, as Cabrera confided to Rosario Hiriart, her *Contes nègres de Cuba* was "accidentally" published in France:

> One day I was chatting with Miomandre about a black pumpkin that I bought at the Marché aux puces—I really liked black art, that is, I was attracted to exotic arts—as we were chatting about the pumpkin and another piece that I also bought at the market: a guiro. From there we started to talk about black people, their culture, etc. (Francis was very enthusiastic about these topics.) I told him that I was writing some short stories to entertain Teresa with whom he was also a close friend, and he asked me to show them to him. He liked them and, on his own initiative, gave them to Paul Morand who wanted them for the collection he was in charge of at Gallimard.[9]

It could be argued that Cabrera's "accidental" publishing of her *Contes nègres* is equivalent to Scheherazade's storytelling in the *Thousand and One Nights*, where, like the legendary character, she aimed to use literature as a postponement of the future (a way to put off or at least put off thinking about Teresa's imminent death). Cabrera's papers attest to a perpetual struggle between the death drive and archival desire, between destruction and forensic preservation. If her future was initially shattered by the Cuban Revolution, other aspects of her life were also erased or, to borrow a phrase from Molloy, "riddled with gender disquiet."[10] Cabrera's biography was reshaped by

9. "Un día hablando con Miomandre sobre una calabaza negra que yo había comprado en el 'Marché aux puces' —me gustaba mucho el arte negro, es decir, me atraían las artes exóticas— estábamos conversando como decía acerca de la calabaza y otra pieza que también había comprado, un guiro. De aquí pasamos hablar de los negros, de su cultura, etcetera.... (Francis era muy entusiasta de todo eso), le conté que tenía una serie de cuentos que escribía para entretener a Teresa, de quien él era también muy amigo, y me pidió que se los enseñara. Le gustaron y por su cuenta se los llevó a Paul Morand, que los quiso para la colección que dirigía en Gallimard." Rosario Hiriart, *Lydia Cabrera: Vida hecha arte* (New York: Eliseo Torres & Sons, 1978), 75.

10. For Molloy, "gender disquiet" is central to de la Parra's biography. Molloy, "Disappearing Acts," 233.

the ideological maelstrom that transformed her world after 1960, the year she left Cuba. Despite the fact that Cabrera's personal papers were made public after her death in 1991 by the anthropologist Isabel Castellanos, they offer few biographical details or information about her departure from Cuba; moreover, they do not shed light on the circulation and distribution of desire between Cabrera and her lovers in Paris or Havana.[11]

I can't help but invoke the powers of a specific figure of speech, namely, metonymy, to fathom the thin difference between personal papers and the archive in extrapolating the central motivation for Cabrera's visit to the Alpine areas of Leysin and Vevey: a small envelope, handwritten and signed by Mlle. de la Parra to Cabrera, sometime at the beginning of the 1930s. The back of the envelope has a map of Lausanne and its surroundings stamped in blue ink, making it look like a spectral irony. It reads: "The Swiss Lido-Centre for Excursions."

ETHNOGRAPHY AS AVANT-GARDE

For Cabrera (and many notable Latin American artists and writers active in the twentieth century), Paris proved to be a productive place for the incubation of new and even old ideas, offering opportunities to meet stimulating writers, critics, scholars, and artists who were either involved in the making of modern art or were testing new approaches to anthropology. In the words of Octavio Paz, "Latin American cosmopolitanism is not a form of uprootedness, nor our

11. The relationship becomes evident in the numerous letters in which María Teresa de Rojas, Cabrera's life companion since the 1940s, is addressed by the different correspondents who asked about Titina or Dame Titina. There is also a gossipy letter written in French by Francis de Miomandre that, due to its abstruse handwriting and intimate content, has never been quoted; this letter describes the sexual misconduct of Rojas's former husband, then a diplomat working in Paris. The letter is in the Cuban Heritage Collection at the University of Miami Libraries.

nativism a provincialism. We are condemned to search in our land another land, and in the other, our own."[12] Moreover, as Molloy suggests, geographic displacement also offered Cabrera, Mistral, and de la Parra a place to be (sexually) different and a sheltered place to write.

By the end of the 1920s, Cabrera "frequently visited the picturesque village of Fontenay-aux-Roses, where artist Alexandra Exter lived, not far from Fernand Léger."[13] She introduced the exiled Russian artist to her friend Amelia Peláez, then an aspiring painter who cruised from the Caribbean to the Atlantic with Cabrera to study art in Europe. Exter, a mature protagonist of the cubo-futurist avant-garde, became a mentor to the young Cubans and a role model to Cabrera, who was struggling to become an independent professional woman long after the death of her dominant father. In a letter sent from Switzerland to Cabrera, dated Tuesday, September 27, 1933, de la Parra recounted: "Today I wrote to Mme. Exter, almost exclusively to let her know how much you love her and the happiness that you feel being under her shadow. There is no way to pay back somebody whose influence is as favorable as hers is on you."[14]

In 1930, Cabrera completed her courses at the École du Louvre, where she spent over two years studying painting and making trips to Italy, some of them with de la Parra. The same year, they traveled to Cuba for a short stay of three months before returning to Paris. Cabrera recalled, "It was in Paris where I got interested in Africa... through

12. Octavio Paz, "José Guadalupe Posada y el grabado latinoamericano," *México en la obra de Octavio Paz, III: Los privilegios de la vista* (Mexico City: Fondo de Cultura Económica, 1987), 188. I thank Natalia Majluf for directing me to this reference.

13. See Lydia Cabrera, "Memories of Alexandra Exter," in this volume, translated by Christopher Winks.

14. See the letters of Teresa de la Parra to Lydia Cabrera in the Cuban Heritage Collection at the University of Miami Libraries.

my studies on the Orient. . . . I went back to Cuba and I immersed myself in the research of the old sources."[15] It was during this period in the French capital that she began a long-standing relationship with her black informants, descendants of slaves who were deeply involved in the practice of the different *reglas* of Afro-Cuban religions: Omí Tomí (Teresa Muñoz), Oddedei (Calixta Morales), and José de Calazán Herrera, among other elderly leaders of black communities established in Havana, Matanzas, and Trinidad. Their secret knowledge of diasporic African myths, cosmogonies, and rituals preserved after abolition prompted the idea for her *Contes nègres de Cuba*, which included stories first published in scattered form until they were compiled in the Gallimard edition of 1936.[16]

Cabrera befriended Exter sometime at the end of the 1920s during a twilight chapter of the latter's Parisian life, when the Russian artist was teaching stage design at Fernand Léger's Académie Moderne. Born in Kiev, Exter "cultivated an abiding interest in Ukrainian folk culture, which she studied, promoted, and exhibited, often incorporating indigenous iconographic references into her own studio work," an interest very much attuned to Cabrera's attention to the folklore and myths of African culture in France as well as in her own country.[17] During the years

15. Hiriart, *Lydia Cabrera*, 73–76.

16. In 1948, Cabrera self-published a second part, *Por qué . . .: cuentos negros de Cuba*, under the pseudonym C y R (Cabrera and Rojas), the Chicherekú rubric that she would use even in her years in exile.

17. Exter, a well-respected member of the international avant-garde art scene, spent her early years between Kiev and Moscow. She hosted an important art salon in her hometown and traveled extensively to Paris, Berlin, Venice, and Milan. She experimented with new ideas, working as a stage designer for theatrical productions conceived by Gordon Craig and Bronislawa Nijinska. Her innovative designs for Alexander Tairov's Kamerny Theatre's staging of *Salomé* prefigured constructivist decors. See Georgii Kovalenko, "Alexandra Exter," and Olga Matich, "Gender Trouble in the Amazonian Kingdom: Turn-of-the-Century Representation of Women in Russia," in John E. Bowlt and Matthew Drutt, eds., *Amazons of the Avant-Garde* (New York: Guggenheim Museum, 2000), 132.

between wars, Exter was credited for the rediscovery of the medieval tradition of manuscript and book illuminations, which she used as an inspiration to compose colorful designs intended to illustrate poems by different authors, including "Arere Marekén," Cabrera's favorite of her *Contes nègres*.

It was Rosario Hiriart who provided some of the details about the close collaboration that resulted from Cabrera's and Exter's recurrent conversations on the art of illustrating books: "We decided to organize an exhibition. We worked together with great enthusiasm. I wanted to make the drawings and illustrations for several stories by Miomandre, and Alexandra would illustrate one of mine. I selected Arere Marekén as it was funny."[18] "Arere Marekén" is a very short story about the dance between jealousy and repressive rule of a brutal king and a virginal queen, who is clandestinely courted by a young Jicotea (turtle) who defies the king's control of the queen's body. The story features a song written in the Yoruba dialect, which is repeated as a ritornello by the queen, who sings it until she interrupts her chant, allowing the king to figure out that her attention to him was diverted. The story's ending presents a bloody, beaten Jicotea, killed by the king's guards, who reduce his body to parts. Jicotea is both a magical and a gender-ambivalent animal cherished by Cabrera, and in this story with a vague ending, she-he is resurrected to achieve the fulfillment of the queen. The exquisite drawings made by Exter show her ability to present color in its kinetic state as well as her strong knowledge of popular culture and folklore distilled through design. Her illustrations delve into Cabrera's violent approach to storytelling, where humor, repressed desire, and music operate as conduits for transmitting a story of sexual transgression.

18. Rosario Hiriart, "Testimonio de una Amistad," in Isabel Castellanos and Rosario Hiriart, *Arere Marekén,* *cuento negro* (Mexico City: Artes de México, 1999), [page no].

Exter completed the illustrated version of "Arere Marekén" between 1932 and 1933, contributing the calligraphy and transcribing the story without knowing a word of Spanish. The book was presented in 1933 at a group exhibition at the Galerie Myrbor along with other publications illustrated by Amelia Peláez, André Lhote, André Derain, and Cabrera, among others, including an exhibition brochure written by the poet Paul Valéry. Galerie Myrbor was a small space devoted to presenting the work of the avant-garde Parisian circuit; it belonged to Marie Cuttoli, an Algerian-born French patron who commissioned carpet cartoons and produced tapestries and textiles with modern artists.[19]

Interestingly, Cabrera orchestrated the exhibition just a few years after destroying her own paintings, an act that marked the end of her visual arts practice: "I conducted a review of all that I had painted to conclude that what I made—and it was a lot—was very bad. I burned everything except for two paintings that the concierge asked for and I gave them to her. This was in 1929."[20] Perhaps her participation in the exhibition after this incident was an interlude triggered by the transition to becoming a committed independent scholar of Afro-Cuban culture; or maybe it was a way to provide some support to her impoverished mentor, Alexandra Exter. Nonetheless, the exhibition occurred during a complicated moment for Cabrera: her mother had

19. Galerie Myrbor was part of Maison Myrbor, owned by Cuttoli, who was very close to Pablo Picasso and with whom she collaborated on important tapestries. She was also credited for reviving the art of Gobelins in the modern era. See www.metmuseum. org/art/libraries-and-research-centers/leonard-lauder-research-center/programs-and-resources/index-of-cubist-art-collectors/cuttoli.

20. "De todo lo que tenía pintado hice una revisión, pero llegue a la conclusión de que lo que había hecho —y era muchísimo—, era muy malo. Lo quemé todo excepto dos cuadros que me pidió la portera y se los regalé. Esto fue en el año 1929." See Hiriart, Lydia Cabrera, 145.

passed away in Havana; de la Parra had become seriously ill; and her financial situation in France was not completely secure due to a period of political turmoil in Cuba.[21]

44 In 1933, Cabrera published "La Pintade miraculeuse," one of her *Contes nègres*, in the magazine *Les Nouvelles littéraires*, followed by "La vase de l'Almendares" in *Cahiers du Sud* (1934); and some other short stories published as "Contes cubains" were included in *La Revue de Paris* (1935), all translated by Miomandre, who presumably used his connections to make some noise on behalf of the young Cuban writer. If we pay attention to Cabrera's later accounts of this process, she was not entirely aware of Miomandre's chess-like moves to get the stories out before they were published by Gallimard. However, the book was reviewed by the influential critics Jean Cassou and Émilie Noulet, and praised by Miguel Ángel Asturias (who was also published by Gallimard), and the intellectual establishment in Cuba, including Fernando Ortiz and Alejo Carpentier.

Between World Wars I and II, the surrealist revolt agitated the Parisian art circles, questioning the relevance of rationalism in the West. At the same time, the parallel discussion of what the philosopher Lucien Lévy-Bruhl defined as the "primitive mentality" entered the public discourse, triggering critical contributions on different disciplinary fronts, including anthropology, art, and politics, as well as a concomitant cross-examination of the realities of the different populations living in the French colonial territories, non-Western folklore, religions, and

21. These issues are obliquely elucidated in the profuse epistolary exchanges with de la Parra, who, some time toward the beginning of the 1930s, commented about Exter's terrible trauma resulting from the suicide of her husband.

22. In *Primitive Mentality* (1922), Lucien Lévy-Bruhl describes the different operations of thought by non-Western people, not in terms of a defect or constitutional inability, but as a cultural trait. See Lucien Lévy-Bruhl, *La mentalité primitive* (Paris: Librairie Felix Alcan, 1922).

myths.[22] It is not accidental that Cabrera mentioned, with great admiration, her brief encounter with Lévy-Bruhl at a lecture during those years.[23] At the time, when the Cuban writer was in the process of composing her twenty-two *Contes nègres*, Marcel Griaule and his team of experts were embarking on the Dakar-Djibouti mission to East and West Africa (1931–33), organized by the Institute of Ethnology at the University of Paris and the National Museum of Natural History, with the support of Pablo Picasso, Charles and Marie-Laure de Noailles, and Raymond Roussel, in addition to corporate sources such as the Rockefeller Foundation and Ford Motor Company. The Dakar-Djibouti mission was an important scientific enterprise as well as a French colonial initiative that planted the roots for the later foundation of the Musée de l'Homme, leading to a radical revision of anthropology and the birth of modern ethnography.[24] Curiously enough, the mission was at the center of the debate propelled by the pages of the avant-garde magazine *Minotaure*, in which modern art (surrealism) and primitivism were united.[25]

Michel Leiris, a dissident writer of the surrealist group, describes the motivations underscoring these new approaches: "I wanted to arrive at a general anthropology through the observation of myself and through the

23. See Hiriart, *Lydia Cabrera*, 157.

24. Created in 1937, the Musée de l'Homme absorbed the collections of the Musée d'Ethnographie du Trocadéro, whose director, Paul Rivet, and assistant director, Georges-Henri Rivière, were part of the Dakar-Djibouti mission. After the African expedition lead by Griaule, 3,500 collected objects were displayed at the museum in the Trocadéro, which became the Musée de L'Homme. See Agnès de la Beaumelle, Marie-Laure Bernadac, and Denis Hollier, *Leiris & Co* (Paris: Gallimard-Centre Pompidou-Metz, 2015).

25. The second issue of *Minotaure* was a special edition dedicated to discussing the Dakar-Djibouti mission from the perspective of its organizers. *Minotaure* was active from 1933 to 1939 and was edited by Albert Skira and Efstratios Tériade, with the intellectual guidance of André Breton and Pierre Mabille.

observation of people from other societies."[26] Leiris, who was the managing editor of the emblematic magazine *Documents* and a contributor to *Minotaure*'s special edition on the Dakar-Djibouti mission, acknowledged the enormous influence of the ethnologist Marcel Mauss, whose classes he attended before embarking on the mission. According to Leiris, "Mauss recommended that researchers keep travel notebooks alongside their inquiries in the field."[27] Interestingly, as Leiris noted, Mauss also engaged in an important discussion of what he defined as "literary ethnography," a concept he applied to Lafcadio Hearn's transcriptions and compilations of Japanese traditional ghost stories that were about to disappear.[28]

If we remember that Cabrera audited classes at the Sorbonne on the history of religions and Eastern cultures, it is not difficult to link Leiris's intellectual contextualization of the period to the narrative strategy deployed in her *Contes nègres de Cuba* and further developed between 1940 and 1950 in *El Monte*, her masterpiece on the study of Afro-Cuban religions, magic, superstitions, and folklore. Edna Rodríguez-Mangual describes the type of scholarship Cabrera developed in *El Monte*: "The challenge presented in *El Monte* is of an ontological and hermeneutical variety: What kind of text is it? How can it be classified? . . . The first clue lies in the title itself; rather than clarify, the title confuses the reader: the note in parenthesis indicates that

26. See Sally Price and Jean Jamin, "A Conversation with Michel Leiris," in *Current Anthropology* 29, no. 1 (February 1988): 24.

27. Leiris served as secretary-archivist of the Dakar-Djibouti mission and was part of the editorial board of the magazine *Documents*, which spearheaded the dialogue about the connections between avant-garde art and primitivism. See Leiris, as quoted in Brent Hayes Edwards, "Introduction to the English Edition," *Phantom Africa* (Calcutta, London, and New York: Seagull Books, 2017), 11.

28. Mauss discussed this topic in his lectures at the Sorbonne. See Sally Price and Jean Jamin, "A Conversation with Michel Leiris," 24.

the reader is dealing with a religious book, but also one that addresses magic and superstition."[29]

It is possible to compare Cabrera's blend of both ethnographic oral traditions and fiction to Leiris's personal account of his African experience in the field. Specifically, Leiris's *Phantom Africa* (1934) is a travel notebook written with rigor and systematic disposition during the Dakar-Djibouti mission, where he shifts the ethnographic method toward a diaristic approach.[30] Moreover, Leiris mingles a subjective-objective perspective with ethnographic observation that can be compared to Cabrera's elaboration of the *Contes nègres*, which she originally presented as transcriptions from her informants, but later admitted were fictional versions of the Afro-Cuban myths recovered in her fieldwork.

Cabrera's subsequent use of notebooks acquired from some of her black informants about religious practices and the use of local herbs and plants deserves further exploration. The relationship between Cabrera and Afro-Cuban primary sources is paradoxical, as she claimed to have used only oral stories that she heard from her old black informants, combined with accounts of her own experiences of the ceremonies and rituals that she attended; however, there is evidence to indicate that she may have consulted some of these notebooks.[31] Her archive includes a panoply of notebooks, random manuscripts, and typewritten transcriptions of older letters (from de la Parra, Mistral, and Miomandre). Cabrera stated that she did not type any

29. Edna Rodríguez-Mangual, *Lydia Cabrera and the Construction of Afro-Cuban Identity* (Chapel Hill: University of North Carolina Press, 2004), 64.

30. Hayes Edwards, "Introduction to the English Edition," *Phantom Africa*, 11–12.

31. Erwan Dianteill and Martha Swearingen, "From Hierography to Ethnography and Back: Lydia Cabrera's Texts and the Written Tradition in Afro-Cuban Religions," *Journal of American Folklore* 116, no. 461 (Summer 2003): 279–80.

piece within her intellectual production nor did she dictate her writings to her assistants. Intriguingly, there is a handwriting discrepancy between some notebooks and the manuscripts of her short stories held in the Lydia Cabrera Papers at the University of Miami. There are a few notebooks in which the handwriting and style seem to belong to a different author, which confirms what Erwan Dianteill and Martha Swearingen have suggested about vernacular written sources used by Cabrera.

When she returned to Cuba in 1939, Cabrera devoted herself to a systematic study of the African diasporic populations in Havana, Matanzas, Las Villas, and Trinidad, and she embarked on extensive field trips to those localities with her collaborator, Josefina Tarafa, and her life companion, María Teresa de Rojas. She also witnessed a voodoo ceremony with anthropologists Pierre Verger (Fatumbi) and Alfred Métraux.[32] Her involvement with the avant-garde remained associated to ethnographic writing, and the translations into Spanish of two strategic texts, *Retorno al país natal* and *Granito gráfico*, by the poet Aimé Césaire and the writer-philosopher Roger Caillois, respectively.

THE SPECTERS OF EXILE

An exile lives in the margins of history, in life but without a place. Having been expelled from her or his own life,

32. Both Alfred Métraux and Pierre Verger made a trip to Cuba in 1957 with Cabrera. Métraux was a Swiss anthropologist who spent time in Argentina and other countries in South America. He published an important study on Haitian Vodou ceremonies. Along with Georges Bataille and Paul Morand, who was the editor at Gallimard of *Les Contes nègres de Cuba*, Métraux also participated in the exhibition *L'Art precolombien* (1928), the first ethnological examination of pre-Hispanic cultures in Paris. Pierre Verger (Fatumbi) was a French photographer-anthropologist who studied African religions and myths in Nigeria and Benin; he compared them to Afro-Brazilian cults in Bahia, where he settled in the 1960s. Verger was very close to Cabrera, and his letters attest to his great admiration of her intellectual reach.

she or he is not condemned by history but to history, as life is defined only in the liminal space of the ruins of the past. Philosopher María Zambrano, a refugee since the Spanish Civil War, argued that "the first answer to that formulated or tacit question of what makes one an exile is very simple: because they left me with a life, or to be more precise, because I was left in life."[33] In 1962, Zambrano, who described Cabrera a decade earlier as the "poet of metamorphosis," wrote a very peculiar letter from Rome in which she inquired about Cabrera's new life in Miami, mentioning that Germán Arciniegas had shared news about her intellectual work.[34] Zambrano also asked about an application for a Bollinger grant, and talked about some correlated personal texts, including "Carta sobre el exilio" (quoted above), which concerns the experience of being deterritorialized or displaced.[35] Zambrano's letter aimed to raise thorny details about an esoteric gathering attended by her sister Aracelis in Rome, at the home of a couple of young Venezuelans; apparently, the other attendees included young compatriots of the hosts as well as a Mexican writer. The gathering was a séance where, reportedly, a spirit identified as Teresa manifested herself. The spirit revealed to Zambrano's sister that she lived at a hospital in Switzerland and that she loved Iphigenia (obliquely referring perhaps to Cabrera). Aracelis and the spirit proceeded

49

33. María Zambrano, "Carta sobre el exilio," *La razón en la sombra: antología crítica* (Barcelona: Siruela, 2004), 463. The original quote in Spanish from Zambrano reads: "la primera respuesta a esa pregunta formulada o tácita de por qué se es un exiliado es simplemente esta: porque me dejaron la vida, o con mayor precisión: porque me dejaron en la vida."

34. Zambrano published her essay on Cabrera in *Orígenes* (1950), the most prestigious Cuban magazine, circulating 1944–56, published by José Lezama Lima and José Rodríguez Feo, and often compared to the Argentine *Sur*.

35. Dated January 30, 1962, this is a typewritten letter with manuscript annotations and a signature in blue pen by Zambrano.

to have an exchange:

> Aracelis: Are you Teresa de la Parra? Spirit: Yes. Aracelis: Can I do something for you, do you want to tell me something for somebody else? Spirit: Yes, Lydia. Aracelis: Is she alive? Spirit: Yes. Aracelis: Where? Spirit: In Florida. Aracelis: What do I say to her? Spirit: To forget. Aracelis: Forget what, the Cuban stuff? Silence. Work? Silence. Economic constraints? Silence. Love? Silence. Then, what should I tell her? Spirit: Forget, forget, forget.[36]

Zambrano pleaded with Cabrera not to keep the letter, suggesting that her friend burn it upon reading it. However, the letter survived, and is currently buried amid unimportant clerical documents at the Cuban Heritage Collection.

In 1960, the word *exile*, when applied to a Cuban political refugee in the United States, evoked the idea of something suspicious and uncomfortable at the same time. Cabrera left Havana that year with María Teresa de Rojas to become an archivist of Afro-Cuban cultures in Miami, a city that she described as a "desert for the spirit."[37]

Cabrera created the heteronym Armando Córdova, a bohemian artist who drew Afro-Cuban motifs and androgynous compositions of fantastic creatures, demonstrating the likely influence of Ovid's *Metamorphoses*. Córdova was the subject of an article by Cabrera for *Alacrán Azul*, a short-lived magazine edited in Miami by Juan Manuel Salvat and directed by José Antonio Arcocha and Fernando Palenzuela, with contributions by Cuban expatriate writers including Guillermo Cabrera Infante and Octavio Armand. Among the drawings credited to Córdova are examples elsewhere credited to Cabrera, including the cover illustration for Ediciones Universal's third edition of *Cuentos negros de Cuba*

36. "¿eres Teresa de la Parra? sí. ¿quieres algo que yo pueda hacer, decirme algo para alguien? sí, Lydia.¿Vive? sí. ¿Dónde? En Florida. ¿qué le digo? olvidar. ¿olvidar qué, lo de Cuba? Silencio. ¿el trabajo? Silencio. ¿las preocupaciones económicas? Silencio. ¿el amor? Silencio. Entonces, ¿qué le digo? Olvidar olvidar olvidar."

37. Lydia Cabrera, "Armando Córdova," *Alacrán Azul* (Miami), no. 2 (1971): 94.

(2012) and the English translation, *Afro-Cuban Tales* published by Bison Books (2005).

The correspondence accumulated by Cabrera from that point to the date of her death in 1991 includes numerous letters from Reinaldo Arenas, Gastón Baquero, Roger Bastide, Guillermo Cabrera-Infante, Roger Caillois, Juan Liscano, Alfred Métraux, Octavio Paz, Angel Rama, Pierre Verger, and Zambrano. There are airmail letters from a number of students, researchers, and academics in the fields of anthropology, ethnology, sociology, literature, art, music, and Caribbean, African, religious, cultural, and film studies, among many other disciplines, speaking to the range of Cabrera's understated influence on many fronts. We have access only to one end of these prolific epistolary exchanges. However, in the case of Verger (whose letters to Cabrera cover a thirty-year period), for example, it is crucial to have both sides of the exchanges in order to better follow Cabrera's intellectual paths undertaken in dialogue with a close friend and colleague, who often reviewed with her the interpretation of specific issues relating to Afro-Cuban religions and myths in order to compare them to equivalent subjects in Nigeria, Benin, or Salvador da Bahia. Their continuous collaboration produced an archipelagic pathway between Africa, the Caribbean, and South America, including additional lines of investigation enhanced by Roger Bastide, according to the correspondence at the Cuban Heritage Collection.

Verger, Caillois, and Bastide often recommended Cabrera for grants, awards, and international symposia to secure her with some income during the stark transition from a wealthy life in Havana to a frugal and sometimes

challenging living as an émigré late in life, deprived of patrimony and without formal academic credentials that would enable her to teach. Caillois sent a supportive letter the very year Cabrera moved to Miami, offering her a freelance job overseeing the translations of historical materials from Latin America, such as *El Periquillo Sarniento* published by UNESCO.[38] A decade later, Caillois authorized Cabrera to translate and publish his text *L'écriture des pierres*, insisting that his language was very difficult, even abstruse, and that the only person he could possibly trust for the translation was Cabrera.

If we look at Caillois's text, presumably translated by Cabrera, from *L'écriture des pierres* (1970) and place it next to Aimé Césaire's *Cahier d'un retour au pays natal* (1939), we can discern a picture of Cabrera's poetic trajectory bifurcated in two threads: one dedicated to the exploration of the language, religions, myths, and cosmogonies of the African diaspora in Cuba (and to some extent the Caribbean), and another centered on the bottomless examination of the revolution as a transformation of the past.[39] Césaire's long poem-manifesto on the double sense of alienation of being in Martinique, with the open wounds of its history of slavery and colonization, and of being separated from the African heritage was partially published in the Parisian leftist magazine *Volontés* in 1939, and translated by Cabrera as early as 1942; it included a prologue by Benjamin Péret and illustrations by Wifredo Lam in a three-hundred-copy print run.[40] By contrast, Caillois's abstract rumination about the origins and transformation

38. A satiric nineteenth-century Mexican novel by José Joaquín Fernández de Lizardi.

39. Although the translation is not signed, it is presumably Cabrera's.

40. The version published in *Volontés* was shorter than the complete poem composed by Césaire and similar in length to Cabrera's. Curiously, Cabrera modified the original title.

of minerals was beautifully published by Skira in a limited edition in Paris only the year before a chapter was translated as "Granito gráfico" and included in the second and last issue of *Alacrán Azul*. If Césaire's poem is a montage of history, surrealist imagery, and brutal lyricism, Caillois's book, as suggested by E. M. Cioran, serves as a fantastic guide to the primal indetermination of rocks in their lack of narrative foundation and the mystery of their making and transformation from high temperatures in perpetual combustion with minerals.[41] It also attests to the author's obsession with the origins of a world that preceded men and reason. Nonetheless, both Césaire's and Caillois's works reflect a degree of pessimism and affirm Cabrera's bold choices in translating fragmented and abstract pieces that deal with two forms of violence and ontological transformation, one racial and the other metaphysical. Such choices also served as attempts to reconcile with the indeterminate and binary condition of an exile: being left with a life and being left in life. These choices reflect Cabrera's strong archival impulse despite her desire to mask, reinvent (and selectively destroy) her personal history.

Dedicated to Yolanda Pantin

41. E. M. Cioran, "Fascinación del mineral," in Roger Caillois, *Piedras* (Madrid: Siruela, 2016), 11–16.

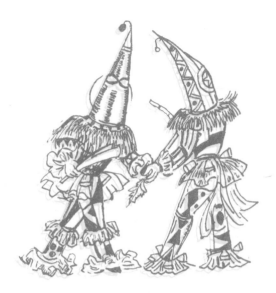

Hans Ulrich Obrist

ARERBAC ARERBAC

On the day that I began writing this text, a section of the Morandi bridge in Genoa, built in the 1960s to connect Italy to the French border, collapsed. The anxieties of our own era resonate in this tragedy, an embodiment of how the dialogue between countries has resorted to either fundamentalist isolation or nationalistic homogenization. To address these urgent concerns of the twenty-first century, we need to go beyond the fear of pooling knowledge. We need to listen to artists and writers who can act as bridge-builders.

Édouard Glissant points to the importance of global dialogues in which local differences are not negated but

produced. His poetry, novels, and philosophy have such urgency, especially now, to prevent an ever increasing cultural homogenization. His critique of isolation and fundamentalism is something that Glissant shares with another Caribbean intellectual, Lydia Cabrera, who not only built bridges between cultures but also between disciplines. As a fiction writer, she critiqued the fetishization of decontextualized African art and artifacts among the Parisian elite. As a translator, she encouraged solidarity between preeminent thinkers such as Aimé Césaire and artists of the Caribbean like Amelia Peláez and Wifredo Lam. She was a painter, a cosmologist, a linguist, an ethnographer and anthropologist, a botanical taxonomist, and, at the same time, an anti-colonial force. Cabrera was not one but many.

Born into a wealthy family, Cabrera became the preeminent scholar of Afro-Cuban culture and religion, relocating from Havana to Paris in the 1930s, only to return to Havana due to rising fascism. In an interview where Cabrera reflected on her experience in Paris, she was described as discovering Cuba on the shores of the Seine.[1] After the Cuban Revolution, Cabrera was forced to live in exile between Miami and Madrid. Nevertheless, she continued her essential work recording the traditions and languages of the Yoruba and Bantu, cultures that continued to grow in the Americas, complicating a nationalist identity that worked to exclude those of the African diaspora. Her legacy provides a critical alternative to the writings of her brother-in-law, the anthropologist Fernando Ortiz, especially his coinage of *transculturation*, a term he employed to critique the colonial narrative of progress found in the

1. Rosario Hiriart, *Lydia Cabrera: Vida hecha arte* (New York: Eliseo Torres & Sons, 1978), 72.

anthropological jargon of the period, which suggests that colonized cultures only assimilated and that this was beneficial.[2] Ortiz's concept of transculturation expands the consideration of cultural transitions to include what is lost through contact. Like Glissant's *creolization*, it suggests that cultures should not be seen as ahistorical entities, as they are in continental thought, but in a constant act of convergence, of dis-adjustment and readjustment.

Cabrera's expansion of transculturation forces us to think through our own spectatorship; we are never only objective diagnosticians but always participants. In Cabrera's *Afro-Cuban Tales*, details like tobacco, guitars, and "ave marías" emphasize that the cultural practices in these stories do not represent a primordial or ahistorical culture that can be used to adorn the reach of a dominant culture, as the modernist appropriation of African artifacts seemed to suggest.[3] Rather, the stories preempt the idea that these aspects could be fully subsumed by maintaining the difference and opacity of Afro-Cuban languages and Yoruba and Bantu cultures, showing that these cultures are constantly evolving and growing, without losing their singularity. In an act of solidarity, Cabrera's selection of details refers to transculturation, forcing us to see how Spanish colonization has altered and created these cultures. Like Glissant, she does not dissect these cultures but allows their customs and habits to stand between the reader and their understanding. In her masterpiece, *El Monte*, Cabrera insists that her informants were the true authors and that she only acted as a medium to spread their knowledge.[4]

2. Fernando Ortiz, *Cuban Counterpoint: Tobacco and Sugar*, trans. Harriet de Onís (Durham, NC: Duke University Press, 1995), 97–103.

3. Lydia Cabrera, *Afro-Cuban Tales*, trans. Alberto Hernández-Chiroldes and Lauren Yoder (Lincoln: University of Nebraska Press, 2004).

4. Lydia Cabrera, *El Monte* (Havana: Ediciones C. R., 1954).

Though her work acts as an archive of the plurality of Cuban cultures, it is important to note that she did not refer to these stories as transcriptions but as transpositions. In *Ayapá: Cuentos de Jicotea*, Cabrera writes of the Jicotea, an amphibious turtle that is believed to be a sacred, gender-fluid trickster in Afro-Cuban religions: "en estas transposiciones, nos limitamos a contar algunos acontecimientos de su vida" (in these transpositions, we limit ourselves to tell of some events of their/his/her life).[5] In this passing reference, Cabrera shows that she is not simply presenting a self-contained artifact, something that exists in a time outside of our own. Instead, Cabrera's transpositions preserve an integral part of oral storytelling: the ability to change and morph, to remain fluid with each performance, according to the audience. Similarly, Glissant imagined his unrealized museum as an archipelago that would refuse synthesis and showcase a network of interrelationships between cultures and traditions, remaining always active. As a storyteller, Cabrera playfully subverts the feeling that one is getting an unaltered historic record by disrupting the reader's temporality. Imagine how surprising it must be to read a text that seems to present a culture's creation myth, only to find the precise year of 1845, perhaps a coy reference to the birth year of the Cuban national hero, Antonio Maceo. Her stories never feel like pure myth or allegory but disrupt these classifications. Her works never feel from a time but always within ours.

Cabrera's notion of transposition along with her engagement with transculturation can be considered as toolboxes for our time. Cabrera foreshadows the disjunction of elements and chronology that has become so much a fixture

5. Lydia Cabrera, *Ayapá: Cuentos de Jicotea* (Miami: Ediciones Universal, 2006), 18. See also R. Valdéz-Cruz, R. "Los cuentos negros de Lydia Cabrera transposiciones o creaciones?" *Honenaje a Lydia Cabrera* (Miami: Ediciones Universal, 1978).

of our digital culture. Her transpositions recreate, shift, and change the recordings and tales of African folklore, occupying both the global and local, and showing us that these traditions are in fact never-ending because they are constantly evolving.

The digital age has caused the emergence of a new spirituality that Cabrera, as an exile, first from fascism and then from the Cuban Revolution, seems to have predicted. In her life as an expatriate, she continuously grappled with the conflict between rationality and spirituality, a conflict that prefigures our own and left a mark on her work. She blurred the boundaries between historian and storyteller, between reality and fiction. *El Monte*, which has yet to be translated into English, functions as both scholarship and a sacred text for practitioners of Santería. A sprawling work that stylistically echoes the wilderness of its title, *El Monte* blends the voices of the dead with the then-living, the natural with the supernatural; her words and poetics enact the traces of history found within Cuba's nature. Her environment becomes her praxis. In his preface to *Afro-Cuban Tales*, Ortiz describes Cabrera as delving into a forest of legends, inviting her readers to treat her work with the respect and caution of one wandering through a wilderness.[6] I consider Cabrera not only as an important archivist but as a living memory. I see her as someone who, like Chris Marker, was an ultimate pilgrim, a witness and historian resistant to official histories, someone who was, as the historian Eric Hobsbawm wrote, in relentless "protest against forgetting."

By being many and through her role as a catalyst and instigator, we can consider her as a model for curation in the twenty-first century. She was an anti-colonial force

6. Fernando Ortiz, in Cabrera, *Afro-Cuban Tales*, xiii.

connected directly to the twentieth-century avant-garde. Because cultural homogenization is nothing less than cultural extinction, Cabrera's work models a strategy for survival in our own period, in which the spectre of extinction has become ever more present. Cabrera dedicated herself fully to her work in historically difficult circumstances and in involuntary exile, so it is disconcerting that her work remains ignored. Her legacy deserves revisiting— hence the urgency of this project. All but one of Cabrera's works have not been translated. The world needs translations. My hope is that this project will be the first of many and will become a catalyst for many more translations, as the twenty-first century needs Cabrera. Cabrera is many.

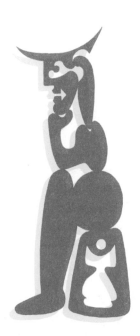

MARTIN A. TSANG

ON BECOMING THE ARCHIVE

The countless pieces of paper, dozens of notebooks, and annotated documents that encompass the more than fifty-five linear feet and eighty archival storage boxes held at the University of Miami's Cuban Heritage Collection represent the intellectual output of Lydia Cabrera.[1] Alongside her artistic and creative projects, including works on paper, *piedras mágicas* (painted smooth stones), embellished Catholic statues, and beaded necklaces signaling her induction into the Afro-Cuban Lukumí religion known as Santería, her

1. The University of Miami's Cuban Heritage Collection is the largest repository of materials on or about Cuba and its diaspora located outside of Cuba. Lydia Cabrera's archive was made possible through the efforts of the founding generation of Cuban librarians, in particular Rosa Abella, and also Ana Rosa Núñez at the Otto G. Richter Library. The entire collection is open to the public, with a growing number of materials digitized and available online at https://library.miami.edu/chc/.

archive also contains personal effects, such as awards, bank statements, royalty checks, and identification. The materials that predate her time in Miami are emblematic of her life and work in Paris, Matanzas, and Havana.

In her 2018 text "Residual Transcriptions: Ruth Landes and the Archive of Conjure," folklorist Solimar Otero observes that Cabrera's archive is not a set of static documents but a methodological approach and appreciation of an ongoing discourse that refers and defers to pivotal interactions with the spirit. An examination of a researcher's papers, such as Cabrera's, contains many dimensions, located on the margins, in jottings, drawings, and unpublished scripts, across a multitude of surfaces and often in defiance of what else is on the page, prompting one to read and research in several ways. Otero, who has worked with both Cabrera's papers and those of the anthropologist Ruth Landes, held at the National Anthropological Archives of the Smithsonian Institution, purposefully examines the nature of these residual transcripts.

Otero maintains that Cabrera's jottings, doodles, and marginalia should not be immediately disregarded nor taken simply as levity in those moments when inspiration was not forthcoming. Instead, the extra details found in archives "inspire ways of reconnecting to the potentiality of their unfinished life stories through the residual arc of their spiritual academic work."[2] In working closely with an archive like Cabrera's, one becomes adept in graphology, the art of intuiting the feelings, the purpose, and the passion that belies the monumental amount of handwriting. By examining the range and reach of her scholarly and personal

2. Solimar Otero, "Residual Transcriptions: Ruth Landes and the Archive of Conjure," *Transforming Anthropology* 26, vol. 1 (April 2018): 3–17.

effects, we gain a clearer understanding of Cabrera's prominence in the transdisciplinary approach to knowledge production through illuminating the processes by which she shaped Afro-Cuban culture. Because her work operates in tandem with complex ties to prominent cultural figures and thinkers, not only in Cuba but also in the Antilles, the wider Americas, Africa, and Europe, Cabrera's work is emblematic of twentieth-century Caribbean intellectualism.

After Cabrera's exile from Cuba in 1960, her name was erased from Cuban literary anthologies, and the books she wrote before leaving became difficult to find in libraries and bookstores on the island.[3] Cabrera continued to publish widely on Afro-Cuban religions, the elements of her homeland that were no longer physically accessible to her. Because of her vantage point in Miami, it can be argued that Cuban religious practices were shaped transnationally. Her work resonates with the displacement and dislocation of forced migrations in the Americas and the need to continue to practice, memorize, and teach. In addition, Cabrera's texts can be read as praxis because of the role that texts play in continuing religious practices while in exile, functioning as manuals and keepers of tradition. While the text may not be anything approaching political, José Quiroga suggests that El Monte is ultimately about exile, that such works bring to the fore the fact that even though the particular cultural context has changed, the need for knowledge remains unquenched.[4] Cabrera became the textual *madrina* (godmother) to many aspiring students of Afro-Cuban religions and Spanish-language readers. For Cuban practitioners living in exile, her books became a

3. Edna M. Rodríguez-Mangual, *Lydia Cabrera and the Construction of an Afro-Cuban Cultural Identity* (Chapel Hill: University of North Carolina Press, 2004).

4. José Quiroga, *Tropics of Desire: Interventions from Queer Latino America* (New York: New York University Press, 2000).

valuable source of religious instruction; many exiled Cuban orisha priests considered her work formative to their practice. She influenced the studies, knowledge production, and dissemination of religious traditions in the Atlantic.

In a visual archive I co-curated at the HistoryMiami Museum,[5] we considered the role of Cabrera's religious practice in her scholarship by presenting archival materials as an altar dedicated to her, inspired by the idea that an altar can act as a gateway or connector between that which is gone or hidden and that which is left behind or created. The altar acts as a stage for an interface between worlds, which "invites the beholder to experience an approach to archives based in feeling, intimacy, and revelation [. . .] aimed at presenting alternative histories and her-stories apprehended in vernacular, idiosyncratic, interactive encounters with remains."[6]

A key element in this project's ability to connect and convey disparate data from geographically diverse sources was the friendship that developed between the photographer and ethnographer Pierre Verger (Fatumbi) and Cabrera in her exile. During the initial period of her exile in Miami, the efforts and friendship of Verger aided her attempts to establish herself. The lives and work of Verger and Cabrera draw many parallels and complement each other, filling in elements of a picture outlined by transculturation in the twentieth century. Working at the margins

5. The exhibition of Lydia Cabrera's archive and related panel and activities were co-curated with Solimar Otero, Eric Mayer-García, and Kay Turner at HistoryMiami Museum, Miami, Florida, October 22–30, 2016.

6. Solimar Otero and Kay Turner, "Honoring Lydia Cabrera's Story: Altar, Performance, and the Living Archive," AFS Review (2016), https://www.afsnet.org/news/320151/Honoring-Lydia-Cabreras-Story-Altar-Performance-and-the-Living-Archive.htm.

as queer scholars,[7] both created encyclopedic works detailing the medicinal and liturgical uses and properties of the sacred orisha herbs in their respective geographies, and, considering Verger's renowned photography, interwove documentation with artistic practices. Born in France in 1902 to an affluent family, Verger was a self-taught ethnographer and photographer. After spending fifteen years from the age of thirty traveling the globe, he was based in Salvador de Bahia, Brazil, until his death in 1991. As a result of their friendship and affinity for furthering knowledge of African religions in the Americas, Verger assisted Cabrera in establishing her academic career outside of Cuba, providing crucial help in identifying potential sources of funding and platforms for her to publish her work.

One of the most beautiful aspects of their friendship is their greetings to one another in their correspondence. Written in French more often than not, Verger would begin his letters with "Chère Yemaya" (Dear Yemaya), referring to the magnificent orisha of motherhood and female power who was Cabrera's tutelar or guardian deity. These greetings grew to include further words of praise poetry—*oríkì*—for the orisha that are traditionally intoned in ceremonies and in public, creating an intimate, spiritual bond between the two. Karin Barber explains that "*oríkì* are felt to capture and evoke the essential characteristics of the subject: to have the most profound and intimate access to its inner nature."[8] Precisely because allusions to history, origin, experience, and relationships are concentrated in

7. While undoubtedly known, Cabrera's and Verger's sexuality was rarely discussed and, if so, only in the most delicate of ways. See the discussion of Verger's sexuality in Iara Cecília Pimentel Rolim, *Primeiras imagens: Pierre Verger entre burgueses e infreqüentáveis* (2009) and Cabrera's in Quiroga, *Tropics of Desire* (2000), and Rodríguez-Mangual, *Lydia Cabrera* (2004).

8. Karin Barber, "Oríkì, Women and the Proliferation and Merging of Òrìsà," *Africa: Journal of the International African Institute* 60, no. 3 (1990): 313–37.

these words and lines, both the practice and composition of greetings and *oríkì* are deeply revered performances of Yoruba oral culture.

Cabrera's published oeuvre has created social visibility and inclusion of queer practitioners and researchers through unstitching biases and phobias in academic inquiry and ethnicity in Afro-Cuban religious history. Investigations of orisha traditions thus invite further research on the subtle theme of the connections between sexuality, author, and practitioner, inviting queer analysis of the production of Afro-Cuban and Afro-Brazilian knowledge and practice.[9] Cabrera's embroidery of sexuality with spirituality makes her work an important site for understanding early queer and lesbian cultural production within Cuban Studies. By locating her work in conversation with Antillean thinkers and artists, queer theory, transnational feminism, and religious transculturation, this direction helps us embrace Cabrera's original bold vision.

9. This interest has been piqued by such seminal work as Ruth Landes's *City of Women* (1947), for its content and comment on homosexuality in the Candomblés of Brazil, and by Randy P. Conner's queer analysis of Santería/Lukumí traditions in Randy P. Conner and David Hatfield Sparks, *Queering Creole Spiritual Traditions* (2004).

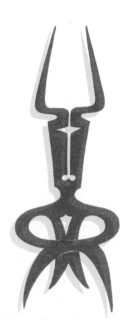

Lydia Cabrera

MEMORIES OF ALEXANDRA EXTER

When we dislike the present, and speaking objectively, it's true that fortune has not favored us with a particularly brilliant one, it is advisable to take refuge in the past, to recall the pleasures one has lived. So I find myself very often in the Havana of my childhood and adolescence, and in the Paris of my youth.

In Paris, I frequently visited the picturesque village of Fontenay-aux-Roses, where Alexandra Exter lived, not far from Fernand Léger.

I don't believe that many Cubans know the work of Alexandra Exter—more precisely, Alexandra Alexandrovna

Exter, née Grigorovich—not even gray-haired ones, nor her relationship to Amelia Peláez, because Amelia was so reserved that she never spoke about her.

This great Russian artist, whom André Boll called "a great force of imagination and harmony," a creator of unmatched originality, was also an educator, an extremely generous teacher, and an exemplary friend.

How did I learn of Alexandra Exter's existence? How did I meet her?

I don't remember exactly. Perhaps my interest in her emerged from something I read about the movement in Russian theater she inaugurated, from my desire to learn from a good source about the avant-garde art that disturbed, attracted, and inspired this former pupil—briefly—of the realist artist Romañach.

What is true is that one day, before I went to Fontenay, in some neighborhood or other, I knocked on her studio door.

Exter was a tall, heavy-set woman—one could call her imposing—but with kindly features and a simplicity that immediately inspired affection.

On that occasion, I went alone to see her. Exter was about to move. The second time, now in Fontenay-aux-Roses, probably around 1928, I came with Amelia Peláez in order to place her under Exter's tutelage. The previous year, during my brief stay in Havana, and at my request, Amelia received a grant from President Gerardo Machado.

That day marked the beginning of a very close friendship between Exter and myself. The poor woman tried to make a painter out of me and was bothered by my continual infidelities to painting, until I hung up my palette once back

for all, even as she was consoled by Amelia's dedication and exemplary tenacity. Amelia never stopped working for a single day.

For a long time, we went frequently to Exter's studio, where, as Simón Lissim recalls, she was habitually surrounded by friends and pupils, never interrupting her work.

George Exter (Georgick), her adoring husband, a former Moscow actor, was kind, welcoming, friendly, and generous. He made everyone visiting his home feel comfortable.

In the Italian Embassy, located in the old and beautiful Hotel du Prince-Talleyrand, I met many truly charming White Russians who surprised me because, contrary to what was believed, they were progressive.

The Italian ambassadors were the Count and Countess Manzoni. The Countess, Silvia Alfonso y Aldama, whom my parents loved dearly, was the granddaughter of Don Miguel Aldama y Alfonso, the exemplary patriot who sacrificed his immense fortune (25 million dollars) for the cause of independence. The Count and Countess had represented Italy in Czarist times and kept their St. Petersburg friends, those who had been able to flee the Bolshevik hell and find asylum in Paris.

I later met, in Exter's house, a few Red Russians (from the Soviet Union) who were passing through Paris and came to see her, always accompanied by someone whose job it was to listen to all the conversations. If the minder were momentarily distracted, another visitor would whisper in her ear, "Ne rentrez pas" ("Don't go back") or "C'est affreux chez nous" ("It's awful back home"). It was very amusing to listen to the Soviets talk. Cars and photographic cameras delighted them; they called them "oto" and "photo."

Unlike other Russians, Alexandra Exter did not make any public statements against the Soviet Union, and the Soviet Union, which avenged itself on so many, never bothered her. Other Russians like her, who were lucky enough to have fled, nearly died of fear when they had to go to their embassy, furnished with secret doors and from which some never emerged again. I remember that many of those appalling cases were commented on in secret. Perhaps, had I not known what the blissful Soviet Union really was, I would have fallen like the majority of Cubans into the *Fidelista* trap. The antipathy that these stories of cruelty and barbarity, the terror experienced by so many wretches, aroused in me was so great that, when I heard that an uncle of the Czar was in Paris and that a group existed that was trying to fight for the liberation of Russia, I wanted to work with them, but was dissuaded by a horrified friend, Antonia Mercé, *La Argentina*, the stellar Spanish ballerina.

During the tragedy of Cuba—which did not take me by surprise—I have recalled many times how often I heard Alexandra and Georgick tell me in their Russian-accented French, "L'Amérique Latine les intéresse beaucoup" ("They are very interested in Latin America"). And that was in 1933.

Many years later, I learned that the Communist machinery had been functioning in an organized manner on my unfortunate island since 1928.

But let us return to Alexandra Exter and her art. Alexandra was twenty-six in 1908 when she went to study in Paris, and she remained six years in the City of Light.

There, she trained with such artists as Braque, Picasso, Marinetti, and others. But her true vocation was the theater,

and, while exploring the possibilities of building a set essentially in three dimensions, she also discovered, as her biographers and critics have written, a new relationship among actors who, dressed in abstract costumes, had to move in harmony with the forms of the set.

Translated by Christopher Winks

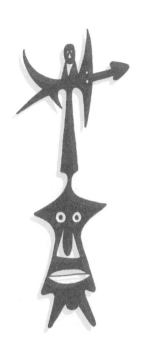

ART BEYOND ART

When Lydia Cabrera met Alexandra Exter in Paris, the work of the Ukrainian artist had already spanned the principal movements of the Russian avant-garde. Exter emigrated from Moscow in 1924, coinciding with Stalin's assumption of power. Her work stretched across painting, illustration, bookmaking, and theater, always maintaining a characteristic rhythm and symmetry. In Kiev and Moscow, her sets and costumes had created sensations through the interplay between cubist, nonobjective forms and performers.

Exter catalyzed artistic movements, bringing avant-garde painting to attention in her native Ukraine. In Paris,

Cabrera became one of the people flowing around Exter, and was affected by her. Cabrera and her friend Amelia Peláez—an artist too—had come to France from Cuba in 1927 to absorb the culture and artistic milieu that Exter embodied: the culture of acceptance and openness that existed in Paris between the wars. Exter welcomed them into her circle of artists, choreographers, writers, and directors. Exter was an example of how to survive the dangerous aftermath of revolution, too—a lesson Cabrera took to Cuba and eventually to Miami.

The encounter and friendship with Exter was also an emphatic influence on Cabrera's approach to her own work: Exter foreshadowed the sly, genre-crossing practice that came to define Cabrera's activities. Exter's work did not fit neatly into either of the Russian avant-garde movements of the early twentieth century, constructivism or suprematism; she was never the defender of any orthodoxy. Cabrera's *Afro-Cuban Tales* was influenced by Exter's constructivist gestures. While the stories seem—on the surface—to feed the fetish for African culture among the European intelligentsia, Cabrera is playing with the nascent fields of mythography and structural anthropology, as well as Greek mythology and psychoanalysis. Cabrera's tales, like Exter's works, are complex performances that combine mythopoetics with social critique, using multiple levels of irony.

Cabrera chose her favorite of these tales, "Arere Marekén," for Exter to illustrate for the 1933 exhibition *Expositions de Livres Manuscrits* at Galerie Myrbor in Paris. In Exter's handwritten rendition in Spanish—a language she didn't know—the unpublished tale has misspellings, word omissions, and grammatical mistakes. Cabrera loved the merging of their two voices, and the multiple levels

of transcription, from the Afro-Cuban teller, through Cabrera's memory and imagination, to the brushes of the Ukrainian artist.

In illustrated books, translations, and magazine pieces, Cabrera co-created a third voice, neither completely hers nor that of her collaborators. As Lourdes Gil writes, both Cabrera and Peláez returned from Paris to Havana with a focus on their own origins: "Lydia and Amelia, in their efforts to retrieve primeval Cuban myths and expose the human and natural landscape of a hybrid culture, were pioneers in the rediscovery of this heritage: Amelia in the emblematic abstractions of her art; Lydia in the anthropographic vindication of her research and tales."[1]

"Arere Marekén" concerns a beautiful young queen married to a nameless and jealous older king. On her daily walks to the market she encounters Hicotea, who loves and pursues her until the king intervenes. Though rendered male in the English translation published here, Cabrera used nongendered pronouns to refer to Hicotea in Spanish. A hybrid of tragic nightingale and romantic hero, Hicotea is a figure who crosses sex and gender roles; at the story's end, *their* "coarse" skin is turned "smooth" and "nice to touch."

Cabrera, much like Hicotea (which is the name of a turtle found in the Americas), is clever, and ever a trickster, compounding and transposing identities in her writings and ethnographies, hiding and uncovering herself and her subjects. The autonomy and holism of Exter's approach fed Cabrera's audacity in her own hybrid practice, beyond the distinction between reality and fiction. What Cabrera learned in Paris, she took beyond art.

1. Lourdes Gil, "Pilgrimage to France: The Cuban Painters," *Bridges to Cuba/ Puentes a Cuba* (Ann Arbor: University of Michigan Press, 2015), 368.

→ *Arere Marekén*, 1933
Story by Lydia Cabrera
Illustrations by Alexandra Exter
Illuminated manuscript, 35 pages
Cuban Heritage Collection, University
of Miami Libraries, Coral Gables, FL

LCABRERA

ARERE

MAREHEN

ARERE
MAREKEN

CUENTO
NEGRO
POR
L. CABRERA
ILUSTRADO
POR
ALEX. EXTER

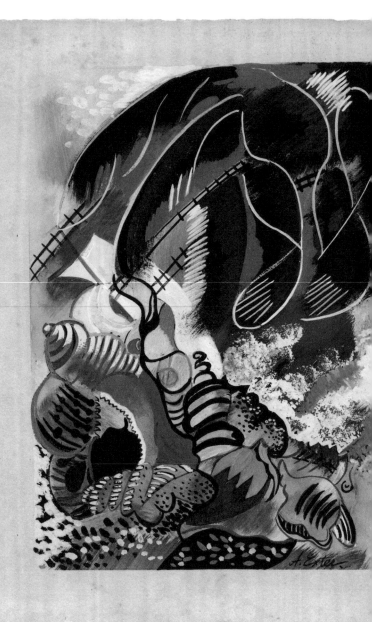

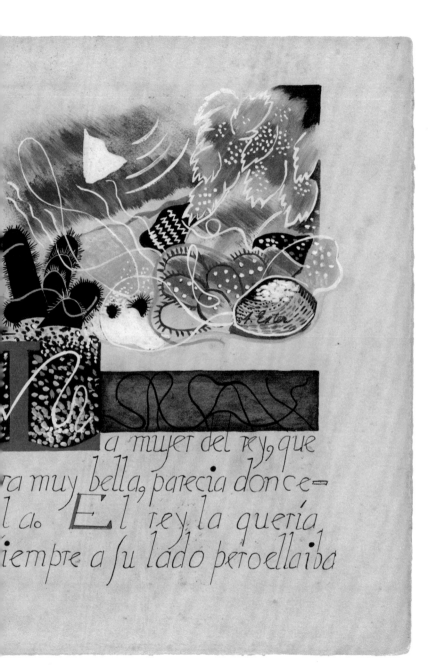

a mujer del rey, que
ra muy bella, parecía donce-
lla. El rey la quería
siempre a su lado pero ella iba

al merado todas las ma-
ñanas. Mientras se
vestia el rej le estaba
diciendo:

—"Arere, no dejara
de cantar.
Arere, no dejarás de
cantar."

Este rey era celoso,
porque Arere parecia
bocella y el empezaba a
er yá viejo —
Este rey tenia una
piedra que el mar
le habia dado. —
Cuando Arere
cantaba, cantaba
la piedra con la
voz de Arere,
y el rey guardaba
el canto, en el

hueco de su mano.

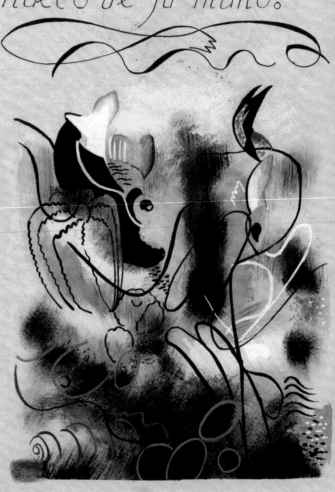

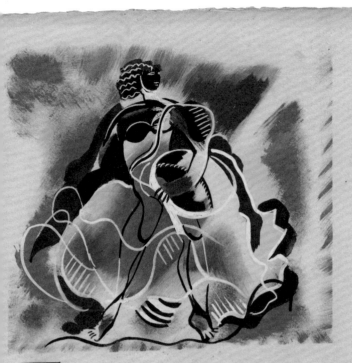

La reina se iba
cantando a la
plaza con bata de
cola muy larga, muy

blanca, y la cesta al
brazo: la reina
Arere cantaba
 así
"Arere Marekén,
Arere Marekén,
Arere Marekén,
cocho ví, cocho va,
Arere Mate kén,
rey no puede estar sin yo!"

Corriendo come una nu-
be, llegaba al mercado:

"Arete Marekén,
Arete Marekén,
Arete Marekén,
cocho vi, cocho va,
Arete Marekén,
rey no puede estar sin yo."

Llenaba su cesta de muchos
colores: corriendo y cantan-
do volvia a palacio y yá el

rey se impacientaba.

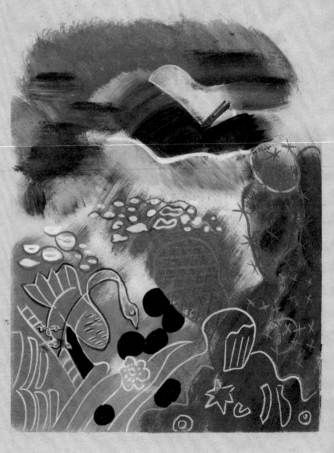

Asomaba Ayer! la mañana, a calle, todo se albo- nozaba, pero nadie, na die se atrevía a mirarla de frente sino era Hico za, que estaba en-

amorado de la mujer de

rey, de Arere Matenér

Un dia por el camino

folo venía, la reina....

Hicotea escondido

en un matojo, yá oia

el oro alegre y

fino de fuf manillaf y

un oleaje de enaguaf

y volantes como camelias
dobles; ya estaba de
vuelta la tenía cantan-
do.; ✦

"A rere Mare ken,
rey no puede estar sin yo."

(Y el rey atento
en su palacio!)

Hicotea salió a su
encuentro.
—Reina, el mismo

Dios te bendiga."

Atere tuvo miedo,
pero dejo de cantar
para decirle:
—"Gracias, Hico-
tea." y luego "que
imprudencia"..
Si el rey lo sabe..."
El rey lo sabe y
me matara," —y le ce-
rró el paso—
"Espera un poco:

qee te gozen miſ ojoſ

Aꞇeꞇe...

Hipotea eꞇa joven;
Aꞇe no podia dejaꞃ
de ſonꞃeiꞃo

Aꞇeꞇe Mateꞃén,
Aꞇeꞇe Mateꞃén,
Aꞇeꞇe Mateꞃén,
cocho vi, cocho va,
Aꞇeꞇe Mateꞃén,
rey nopuedeeſtarſin yo.

"Adiós, Hicotea..."
"Arere, un poco más..."
En la mano del
rey se fué apagando
el canto.

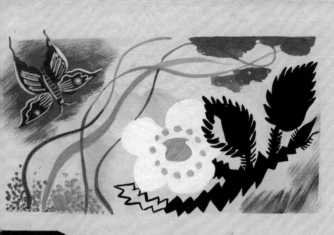

Despues Arete corrió mucho y el corazón le temblaba; temblaba en el canto, temblaba en los dedos crispados del rey, su dueño.

Arete." ¡Pa que calla'
tes. Arete Materené.
—Hoy el camino est
ba lleno de charca'.
Me recogi la cola Pc
cuidar de no marchar
la, rey, me olvidé
de cantar."

"Atete Maten̄én,
Atetê Maten̄én,
Atete Maten̄én,
çocho ví, çochova,
Atete Maten̄én,
rey no puede estar sin y o."

El rey estaba muy aten-
to en su palacio.

Por el sendero so-
lo ya la reina vol
via de la plaza,
entre el revoloteo
de sus palomas
blancas de percal:
otra vez Hircotea
la detuvo: otra vez
Arete dejo de can
tar.

—"Átete! porqé callaste,, Átete Matetén?"

"Hoy perdí una de mis chinelas nuevas Buscandola ,,rey,, me olvidé cantar."

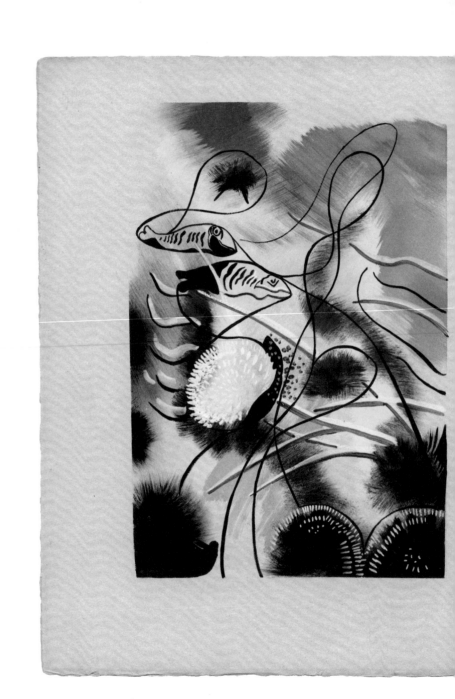

"Atete Matekén,
Atete Matekén,
Atete Matekén,
cocho vi, cocho va,
Atete Matakén,
rey no puede estar sin yo"

El rey estaba atento
en su palacio.

Hicotea en la embos-
cada. Arete venía
corriendo, corriendo
come una nube.
(Y los guardias del
rey la seguian a
distancia)

Hicotea besaba los
pies de la reina.
—Ven Arete: se ha
secado el rocio, y á

la yerba tibia hue
le a sol."

⁓⁓⁓⁓⁓

(Y la mano del rey se
heló de silencio)
Pero llegaron los
guardias, se apoderaron
de Hicotea, se lo
llevaron al rey que
lo vio mozo y dijo
—"Muera a palos!"

⁓⁓⁓⁓⁓

Atete Mateuén,
Atete Mateuén...
Aquella mañana
murió Hicotea de
tantos palos que el
rey mandara: y la

reina lloró, pilando
el maíz, tostando
el café...

~~~~~~~~~~~~~~~~~

Por fin llegó la
noche con la luna
luneta cascabelera
y Hicotea,—todo en
pedazos—resucitó
Y quien diría que su
cuerpo no era áspe
ro, sino duro, liso y
suave!

I antaſ cicatriceſ,
por el amor de A rete,
de A rete Materkén.

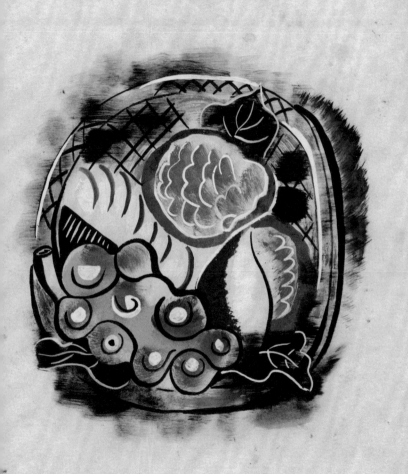

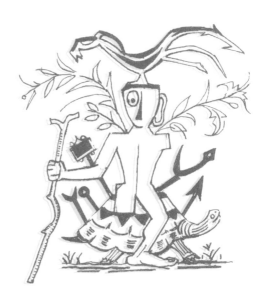

Lydia Cabrera

# ARERE MAREKÉN

The king's wife was a very beautiful, young-looking woman. The king wanted her always to stay close to him, but she used to go to the market every morning. While the king was getting dressed, he would tell his wife:

"Arere, you musn't stop singing. Arere, you musn't stop singing."

The king was very jealous because Arere looked young, and he was getting old.

Now the king had a stone that the ocean had given him. Every time Arere would sing, the stone would also sing with Arere's voice, and the king would hold the songs in the palm of his hands.

The queen would go singing to the market, and she wore a very white gown with a long train. She carried a basket in her hands. The queen sang like this:

"Arere Marekén, Arere Marekén,
Arere Marekén, kocho bí, kocho bá
Arere Marekén, King can't be without me!"

Running like a cloud, she would arrive at the market:

"Arere Marekén, Arere Marekén,
Arere Marekén, kocho bí, kocho bá
Arere Marekén, King can't be without me!"

She would fill her basket with many colors, and she would return to the palace running and singing, while the king was already getting impatient.

When Arere appeared, the morning, the street, everything would rejoice, but nobody, except Hicotea,[1] would dare to look her straight in the face. Hicotea was in love with the wife of the king, with Arere Marekén.

One day the queen was coming alone down the road...

From where Hicotea was hidden in a bush, he could hear the sounds of gold bracelets and of the waves of skirts and petticoats, like double camellias: The queen was coming again, singing.

"Arere Marekén, King can't be without me!"

---

1. Hicotea is a freshwater turtle. Though this translation employs masculine pronouns, the original Spanish employs gender-neutral pronouns to articulate Hicotea's gender fluidity.

(Meanwhile the king was watching and waiting in his palace.)

Hicotea came out on the road to meet her.

"Queen, may God himself bless you."

Arere was afraid, but stopped singing long enough to say:

"Thank you, Hicotea."

But later she said:

"What imprudence! What if the king finds out ...!"

"The king already knows it, and he will kill me," said Hicotea, standing before her... "Wait a moment, let my eyes enjoy you, Arere. That's all I want."

Hicotea was young, and Arere could not stop smiling.

> "Arere Marekén, Arere Marekén,
> Arere Marekén, kocho bí, kocho bá
> Arere Marekén, King can't be without me!"

"Good-bye, Hicotea ..."

"Arere, a little bit more ..."

In the hands of the king, Arere's song was dying. Later, Arere ran too much, and her heart was trembling; she was trembling in her song and in the cupped fingers of the king, her master.

"Arere, why did you become silent, Arere Marekén?"

"Today the road was full of puddles. I held up my train for fear of soiling it, that's why, my King, I forgot to sing."

> "Arere Marekén, Arere Marekén,
> Arere Marekén, kocho bí, kocho bá
> Arere Marekén, King can't be without me!"

The king was attentive in his palace.

The queen was returning alone from the market among the white flappings of her percale doves. Hicotea stopped her again, and Arere stopped singing.

"Arere! Why did you become silent, Arere Marekén?"

"Today I lost one of my new slippers, my King. As I looked for it, I forgot to sing."

"Arere Marekén, Arere Marekén,
Arere Marekén, kocho bí, kocho bá
Arere Marekén, King can't be without me!"

The king was attentive in his palace.

Hicotea was hiding in his ambush. Arere was coming, running, running like a cloud. (And the king's guards were following her from a distance.)

Hicotea kissed the queen's feet.

"Come, Arere. The dew is already dry. . . Already the warm grass contains the perfume of the sun."

And the hand of the king froze in silence.

But the king's guards arrived and captured Hicotea, and took him to the king. When the king saw that he was young, he said:

"Let's club him to death."

"Arere Marekén, Arere Marekén,"

Hicotea died that morning from the clubbing ordered by the king. As she ground her corn and her coffee, the queen cried.

Finally the night arrived with its flirting and festive moon. Hicotea, cut in pieces, came back to life.

And who could have imagined that Hicotea's body was no longer coarse, but was hard, smooth, and nice to touch. So many scars for Arere's love, Arere Marekén's love!

*Translated by Alberto Hernández-Chiroldes and Lauren Yoder*

*Cuentos negros de Cuba*, 1940. Originally translated for *Afro-Cuban Tales*, University of Nebraska Press, 2004.

# Selected Bibliography

## WORKS BY LYDIA CABRERA

"La Pintade miraculeuse, conte nègre de Cuba." Trans. Francis de Miomandre. *Les Nouvelles littéraires*, no. 585. Paris: December 30, 1933: 7.

"Contes nègres de Cuba, la vase de l'Almendares." Trans. Francis de Miomandre. *Cahiers du Sud* 158. Paris: January 1934: 12–22.

"Contes cubains." Trans. Francis de Miomandre. *La Revue de Paris* 42, no. 4. Paris: February 15, 1935.

*Contes nègres de Cuba.* Trans. Francis de Miomandre. Paris: Gallimard, 1936.

*Cuentos negros de Cuba.* Havana: La Verónica, 1940.

*Afro-Cuban Tales.* Trans. Alberto Hernández-Chiroldes and Lauren Yoder. Lincoln: University of Nebraska Press, 2004.

"Bregantino, Bregantín (Conte nègre-cubain)." *Tropiques*, no. 10. Fort-de-France: February, 1944: 12–27.

*Por qué . . .: cuentos negros de Cuba.* Havana: Ediciones C. R., 1948.

"La ceiba y la sociedad secreta Abakuá." *Orígenes*, ed. José Lezama Lima and José Rodriguez Feo. Havana: 1950: 16–47.

*El Monte: Igbo, Finda, Ewe Orisha, Vititi Nfinda (notas sobre las religiones, la magia, las supersticiones y el folklore de los negros criollos y el pueblo de Cuba).* Havana: Ediciones C. R., 1954.

*Pourquoi…: Nouveaux contes nègres de Cuba.* Trans. Francis de Miomandre. Paris: Collection La Croix du Sud, Gallimard, 1954. Part of Roger Caillois's series publishing Latin American writers in French.

*Refranes de Negros Viejos.* Havana: Ediciones C. R., 1955.

*La sociedad secreta Abakuá, narrada por viejos adeptos.* Miami: Ediciones C. R., 1959. Photographs by Pierre Verger.

*Anagó: vocabulario lucumí (el yoruba que se habla en Cuba).* Miami: Ediciones C. R., 1970.

*Otán iyebiyé: las piedras preciosas.* Miami: Ediciones C. R., 1970.

"Armando Córdova," *Alacrán Azul* (Miami), no. 2, 1971: 94–101.

*Ayapá: cuentos de Jicotea.* Miami: Ediciones Universal, 1971.

*La laguna sagrada de San Joaquín.* Miami: Ediciones Universal, 1973. Photographs by Josefina Tarafa.

*Yemayá y Ochún.* Miami: Ediciones C. R., 1974.

*Anaforuana: ritual y símbolos de la iniciación en la sociedad secreta Abakuá.* Madrid: Ediciones R., 1975.

*Francisco y Francisca: chascarrillos de negros viejos.* Miami: Peninsular Printing, 1976.

*Itinerarios del insomnio: Trinidad de Cuba.* Miami: Ediciones C. R., 1977.

*La regla kimbisa del Santo Cristo del buen viaje.* Miami: Peninsular Printing, 1977.

*Reglas de Congo/Palo Monte Mayombe.* Miami: Peninsular Printing, 1979.

*Koeko iyawó, aprende novicia: pequeño tratado de regla lucumí.* Miami: Ediciones C. R., 1980.

*Cuentos para adultos niños y retrasados mentales.* Miami: Ultra Graphics Corp., 1983.

*La medicina popular de Cuba: Médicos de antaño, curanderos, santeros y paleros de hogano.* Miami: Ediciones Universal, 1984.

*Supersticiones y buenos consejos.* Miami: Ediciones Universal, 1987.

*La lengua sagrada de los náñigos, vocabulario Abakuá.* Miami: Ediciones Universal, 1988.

*Páginas sueltas.* Ed. Isabel Castellanos. Miami: Ediciones Universales, 1994.

ESSAYS, REVIEWS, AND INTERVIEWS

Bettelheim, Judith. "Lam's Caribbean Years: An Intercultural Dialogue." In *Wifredo Lam*, 11–21. Miami: Miami Art Museum, 2008.

Bolívar, Natalia, and Natalia Del Río. *Lydia Cabrera en su Laguna Sagrada.* Santiago de Cuba: Editorial Oriente, 2000.

Carpentier, Alejo. "Cuentos negros de Lydia Cabrera." *Carteles.* Havana, 1940.

Cassou, Jean. "Poésie Mythologie Américaine." *Les Nouvelles littéraires*, no. 707. Paris: May 4, 1936.

Castellanos, Isabel, ed. *Consejos, pensamientos y notas de Lydia E. Pinbán.* Miami: Ediciones Universal, 1993.

Castellanos, Isabel, and Josefina Inclán, eds. *En Torno a Lydia Cabrera (Cincuentenario de Cuentos negros de Cuba: 1936–1986).* Miami: Ediciones Universal, 1987.

Castellanos, Isabel, and Rosario Hiriart. *Arere Merekén, cuento negro (edición facsimilar)*. Mexico City: Artes de México, 1999.

Césaire, Aimé. "Introduction à un Conte de Lydia Cabréra." *Tropiques*, no. 10. Fort-de-France: February 1944.

David, Catherine. "El Monte y El Mundo." In *Wifredo Lam*, 13–19. Madrid: Museo Nacional Centro de Arte Reina Sofía, 2017.

Dianteill, Erwan, and Martha Swearingen. "From Hierography to Ethnography and Back: Lydia Cabrera's Texts and the Written Tradition in Afro-Cuban Religions." *Journal of American Folklore* 116, no. 461 (Summer 2003): 273–92.

Guicharnaud-Tollis, Michèle. "Los Cuentos negros de Cuba de Lydia Cabrera: desde la tradición hasta la criollización." *Caravelle*, no. 76–77 (December 2001): 549–58.

Hiriart, Rosario. *Lydia Cabrera: Vida hecha arte*. New York: Eliseo Torres & Sons, 1978.

Hiriart, Rosario, ed. *Cartas a Lydia Cabrera (correspondencia inédita de Gabriela Mistral y Teresa de la Parra)*. Madrid: Torremozas, 1988.

Jiménez, Onilda A. "Dos cartas inéditas de Gabriela Mistral a Lydia Cabrera." *Hispamérica* 12, no. 34/35 (April–August 1983): 97–103.

Lezama Lima, José. "El nombre de Lydia Cabrera." In *Tratados en la Habana*, 144–48. Buenos Aires: Ediciones de la Flor, 1969.

Levine, Suzanne Jill. "A Conversation with Lydia Cabrera," *Review*, Center for Inter-American Relations, New York, issue 31, 1981, 13–15.

Molloy, Sylvia. "Disappearing Acts: Reading Lesbian in Teresa de la Parra." In *¿Entiendes? Queer Readings, Hispanic Writings*, edited by Paul Julian Smith and Emilie L. Bergmann, 230–56. Durham, NC and London: Duke University Press, 1995.

Quiroga, José. "Queer Desires in Lydia Cabrera." In *Tropics of Desire: Interventions from Queer Latino America*, 76–100. New York: New York University Press, 2000.

Rodríguez-Mangual, Edna M. *Lydia Cabrera and the Construction of an Afro-Cuban Cultural Identity*. Chapel Hill: University of North Carolina Press, 2004.

Sánchez, Reinaldo, and José A. Madrigal, eds. *Homenaje a Lydia Cabrera*. Miami: Ediciones Universal, 1978. With contributions by: Eugenio Florit, Ángel Aparicio, Manuel Ballesteros, Gastón Baquero, Ralph S. Boggs, Guillermo Cabrera lnfante, Roger Caillois, Juana Elbeins

dos Santos, Deoscoredes Maximillano dos Santos, Katherine Dunham, Seymour Menton, Sidney W. Mintz, Antonio Olinto, Tora A. O. Sejan, Francisco Gordo Guannos, José A. Madrigal, Matías Montes Huidobro, Rosario Hiriart, Hortensia Ruiz del Vizo, José Sánchez-Boudy, Ricardo Viera, Jorge J. Rodríguez Florido, and others.

Seligmann, Katerina. "Governing Readability, or How to Read Césaire's Cabrera." *Inti: Revista de literatura hispánica*, no. 75 (April 2012): 210–22.

Simo, Ana María. *Lydia Cabrera: An Intimate Portrait*. New York: INTAR Latin American Gallery, 1984.

Szwed, John, with Robert Farris Thompson. "The Forest as Moral Document: The Achievement of Lydia Cabrera." In *Crossovers: Essays on Race, Music, and American Culture*, edited by John Szwed, 61–76. Philadelphia: University of Pennsylvania Press, 2005.

Winks, Christopher. "A Great Bridge That Cannot Be Seen: Caribbean Literature as Comparative Literature." *Comparative Literature* 61, no. 6 (Summer 2009): 244–55.

Zambrano, María. "Lydia Cabrera, Poeta de la Metamorfosis." *Orígenes* 7, no. 25 (1950): 11–15.

## A NOTE ON THE ILLUSTRATIONS
## BY LYDIA CABRERA

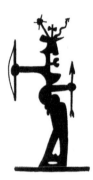

Although Lydia Cabrera destroyed her paintings after graduating from the École du Louvre, she never stopped drawing, whether in notebooks or on miscellaneous research papers. A number of these drawings were originally published in a catalogue for Mnemosyne Publishing Co., Inc.'s Cuban Reprint Series in collaboration with her partner María Teresa de Rojas's publishing house, Ediciones C. y R. Other drawings were published in *Alacrán Azul* (1971), a short-lived magazine edited by Cuban expatriates in Miami to illustrate an article about Armando Córdova, an artist invented by Cabrera.

# CONTRIBUTORS

Hans Ulrich Obrist is the Artistic Director of the Serpentine Galleries and co-curator of the exhibition *Trembling Thinking*. He has curated more than 300 shows, and is a contributing editor to several magazines and journals. His publications include *Mondialité: Or the Archipelagos of Édouard Glissant* and *The Athens Dialogues*.

Gabriela Rangel is the Director of Visual Arts and Chief Curator at Americas Society, where she co-curated *Trembling Thinking*, *José Leonilson: Empty Man*, *Erick Meyenberg: The wheel bears no resemblance to a leg*, and *Told and Untold: The Photo Stories of Kati Horna in the Illustrated Press*.

Asad Raza is an artist and co-curator of the exhibition *Trembling Thinking*. His projects include *Root sequence, Mother tongue* at the 2017 Whitney Biennial, *the home show* in his apartment in New York, and installations at Frieze Projects and the Ljubljana Graphic Art Biennial.

Martin A. Tsang is the Cuban Heritage Collection Librarian and Curator of Latin American Collections at the University of Miami. His work as a cultural anthropologist explores Afro-Asian religiosity in Cuba as well as issues concerning HIV in the wider Caribbean. He is a Junior Fellow in the Andrew W. Mellon Society of Fellows in Critical Bibliography at the Rare Book School.

Christopher Winks is Associate Professor and Chair of Comparative Literature at Queens College/CUNY. He is the author of *Symbolic Cities in Caribbean Literature* and the editor and co-translator, with Adriana González Mateos, of *Los danzantes del tiempo*, an English-Spanish anthology of Kamau Brathwaite's poems.

# AFTERWORD

Americas Society is pleased to partner with the Cuban Heritage Collection of the University of Miami Libraries for this publication on Lydia Cabrera's influence on visual culture in addition to literature, ethnography, and religion. This volume aims to expand Cabrera's outstanding yet unknown legacy as a creative writer and independent scholar. We would like to thank the authors, Hans Ulrich Obrist, Gabriela Rangel, Martin Tsang, Christopher Winks, and Asad Raza, whose contributions help to reinsert Cabrera into the network of intellectuals and modernists working in the Caribbean, France, and around the world in the twentieth century. We are also indebted to Karen Marta, Todd Bradway, and Anton Haugen of Karen Marta Editorial Consultants, and designer Garrick Gott, for their extraordinary effort in producing a stunning book. Diana Flatto and Carolina Scarborough from the Visual Arts team at the Americas Society, and Amanda Moreno and Laura Fedynyszyn from the University of Miami Libraries, also deserve special recognition.

The project *Lydia Cabrera and Édouard Glissant: Trembling Thinking* is made possible by an award from the National Endowment for the Arts, and by public funds from the New York City Department of Cultural Affairs in partnership with the City Council. Additional support is provided by Genomma Lab Internacional and Mex-Am Cultural Foundation. In-kind support is graciously provided by the Consulate General of Switzerland in New York.

Americas Society gratefully acknowledges the generous support from the Arts of the Americas Circle members.

— Susan Segal, President and CEO, AS/COA
Dr. Julio Frenk, President, University of Miami

# Acknowledgments

The editors are grateful to the following people: Mary Caldwell, Margarita Cano, Alessandra Caputo, Elizabeth Cerejido, Suzanne Delehanty, María de Lourdes Dieck-Assad, Estrella de Diego, Jill Deupi, Coco Fusco, Consul General of Mexico to New York City Diego Gómez Pickering, Gladys Gómez Rossié, Celso González Falla, Alexa Halaby, Eugenia Incer, Angelina Jaffe, Inés Katzenstein, Eskil Lam, Orlando Jiménez Leal, Suzanne Jill Levine, Pierre Losson, Laura Macfarlane, Esther Morales, René Morales, Baron Munchausen, Rosamaria Ng, María Helena Rivero, Mary Sabbatino, Wilson Santiago, Max Shackleton, Clarice Oliveira Tavares, Lorraine Two Testro, Jennifer Tobias, Alana Tummino, and Frederic Tuten.

*Lydia Cabrera, between the sum and the parts*

Published on the occasion of the exhibition
*Lydia Cabrera and Édouard Glissant: Trembling Thinking*
October 9, 2018–January 12, 2019

Americas Society
680 Park Avenue, New York, NY 10065
www.as-coa.org/visual-arts

Additional funds for this publication were provided by Pablo Henning.

PUBLICATION
Editors: Karen Marta and Gabriela Rangel
Assistant Editors: Diana Flatto, Anton Haugen
Managing Editor and Production: Todd Bradway
Designer: Garrick Gott
Copyediting: Miles Champion, Melina Kervandjian
Copyrights and Research: Carolina Scarborough

Co-published by Koenig Books, London

Koenig Books Ltd
At the Serpentine Gallery
Kensington Gardens
UK – London W2 3XA
www.koenigbooks.co.uk

Printed and bound by VeronaLibri, Verona, Italy

ISBN 978-3-96098-503-7

DISTRIBUTION
Germany, Austria, Switzerland / Europe
Buchhandlung Walther König
Ehrenstr. 4
D – 50672 Köln
verlag@buchhandlung-walther-koenig.de

UK & Ireland
Cornerhouse Publications Ltd.
2 Tony Wilson Place
UK – Manchester M15 4FN
publications@cornerhouse.org

Outside Europe
D.A.P. / Distributed Art Publishers, Inc.
75 Broad Street, Suite 630
USA – New York, NY 10004
orders@dapinc.com

THIS BOOK HAS BEEN SET IN
DTL DORIAN

AND IS PRINTED ON
MUNKEN PRINT CREAM